A ROADSIDE CAMERA
1895-1915

A ROADSIDE CAMERA
1895-1915

Michael E. Ware
FRPS

DAVID & CHARLES
NEWTON ABBOT LONDON
NORTH POMFRET (VT) VANCOUVER

ISBN 0 7153 6791 9

Library of Congress Catalog Card Number 72-12874

Set in 11 on 13pt Baskerville by Bristol & West Engravers Ltd
and printed in Great Britain by Redwood Burn Limited,
Trowbridge & Esher for David & Charles (Holdings) Limited
South Devon House Newton Abbot Devon

Published in the United States of America by David & Charles Inc
North Pomfret Vermont 05053 USA

Published in Canada by Douglas David & Charles Limited
3645 McKechnie Drive West Vancouver BC

CONTENTS

LIST OF ILLUSTRATIONS

ROADS AND MOTORING SERVICES

MOTORCYCLING

SOCIAL MOTORING

SPORTING MOTORING

ACKNOWLEDGEMENTS

Many people have helped in the production of this book; in particular I should like to single out the following: Michael Sedgwick, for reading the manuscript, correcting it, and adding much useful information and reading the proofs. Eric Bellamy, librarian at the National Motor Museum, who had to put up with my continual foraging through his book-shelves for information. Jill Lindemere for typing the manuscript, and Jane Bailey for writing innumerable letters.

Photographs are reproduced by courtesy of the following: John Bolster, 31; Couzins/ Powney Collection, 52, 53, 62, 63; County Borough of Dudley Library, 123; Epsom and Ewell Public Library, 92; London Transport Executive, 3, 64, 117, 118, 121, 124, 126, 127; Kevin MacDonnell, 83; Mansell Collection, 58, 128; National Traction Engine Club Steaming, 103; Royal Aero Club, 89; Royal Aeronautical Society, 91; R. A. Whitehead, 47, 105; Louis Holland, 111; National Motor Museum, all remaining photographs.

INTRODUCTION

The first true year of the automobile in Britain was 1895. It was then that the roadside began to be transformed from a pedestrian, pedal and equestrian precinct into a highway monopolised by the internal combustion engine. The years that followed were transitional, with both horsedrawn traffic and the bicycle very much in evidence, but the automobile had come to stay and its popularity steadily increased. This is the roadside of the motor vehicle, omitting motor racing, but with a touch of steam here and there.

Photography was well established by 1895, films and plates had become relatively sophisticated and the roll-film camera was being used by adventurous families. It is very probable that the best of the early motoring pictures still lie buried in family snapshot albums, hidden from public view. New models and inventions were recorded by the large brass-bound cameras of the professionals, the Sandersons or the Thornton Pickards. These cameras were mounted on cumbersome wooden tripods, the operator peering out from a voluminous black cloth. The spontaneous recording of accidents and sporting occasions characterise the first twenty years of the motor vehicle's history, but such drama was known only to the few. To the family, car ownership was dramatic enough in itself and the true flavour of the early years is best preserved in family snapshots. Unfortunately, such photographs are hard to obtain, such family treasures often being unwittingly reserved for the lucky relatives and friends.

This view of the British roadside around the turn of the century has been much enhanced by material from the Photographic Library at the National Motor Museum, Beaulieu—possibly the finest of its kind in the world. Some photographs in the Library's collection were originally in the files of professional photographers; others are little more than faded snapshots and dog-eared prints discovered by chance, the negatives of which have long since disappeared. The motor car, even in its infancy, attracted the photographer and the new motor industry used photography to record its many varying inventions.

Manufacturers vied with one another to bring their products to the notice of the public with freak hill climbing or long-distance runs—Land's End to John O'Groats being the obvious favourite in the case of the latter. Until relatively recent times, many manufacturers supplied cars to the customer in chassis form; the client then commissioned a coachbuilder to make a body to his own specification. For this reason no two bodies were identical on some makes of car.

The coachbuilders photographed each newly completed vehicle at their works and great albums were kept as records of their

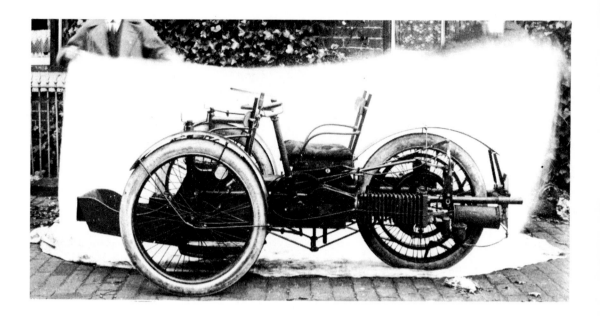

craftsmanship. But these records were dependent on a breed of employee whom the reader will now never meet: the 'man with the white sheet'. He only appears on the negatives from which surviving prints were taken, and had been blocked out by the time the finished print was presented to the customer. Motor vehicles were too large to photograph in isolation from the crowded factory or street, and a light uncluttered background had to be found. Thus photographers resorted to holding a large white sheet behind the automobile, and during the time exposure the sheet was moved backwards and forwards to hide its numerous creases and imperfections. The men holding the sheets appear on many negatives as blurred ghosts, often mounted precariously on high ladders or even lamp-posts.

The early years of motoring were full of excitement and good humour, and the unpredictable machines were approached first with awe and then with abandon. But however light-hearted our retrospective view may be, there were many problems associated with owning and driving a motor car during the first twenty years of its history on the roads of Britain.

The white sheet is used to display an 1896 Bollée Tricar.

BEFORE THE HIGHWAYS ACT OF 1896

1 By the time that the Locomotives on the Highways Act, more commonly known as the Emancipation Act, was passed in 1896, the railways were the prime movers of goods and people in Britain. The canals had brought in the supplies of coal and other raw materials that were crucial to the Industrial Revolution, but road improvements by the Turnpike Trusts in the early 1800s had been expected to make way for a steam-engine revolution in road transport. This was not to be and the burden of communications fell on the railways.

Penal restrictions governing weight and speed, as well as heavy tolls, prevented the steam road coach from catching on; and worse still, such vehicles were exceedingly unreliable. The slower stage and mail coaches ran regularly on the roads and pro-vided an all-important back-up service until the great railway boom of the 1840s and 1850s. Those families who could afford them had a horse and trap; wealthier citizens ran to broughams and phaetons. By the 1880s the more adventurous were resorting to the bicycle for local journeys, and a decade later bicycle touring was an established pastime. It was on the farms that steam was developing as a prime mover, not so much as a means of transport but as a source of power for ploughing, threshing or sawing.

Then came the motor car, first reaching Britain in 1895, and the answer to an inventor's backyard dream. The first practical automobiles to run on our roads were foreign imports from France and Germany, the results of ten years of experimentation and usage.

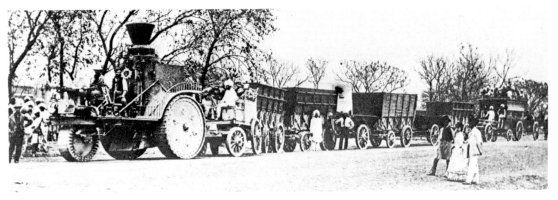

2 The steam engine should have changed the character of road transport in this country, but the laws governing weight and speed precluded this. One of the most successful designers was R. W. Thompson, an engineer from Edinburgh, who had had at least seven road locomotives made for him by 1871. Although they were tested in this country, all of them appear to have been exported to India to the order of Lt R. E. B. Crompton, at least one finding its way to the head of a 'bullock train'. The boilers were, however, found to have a limited capacity, particularly when burning wood, and the solid rubber tyres had to be sheathed in loose metal plates to withstand the wear. Very few early road locomotive pictures survive in Britain.

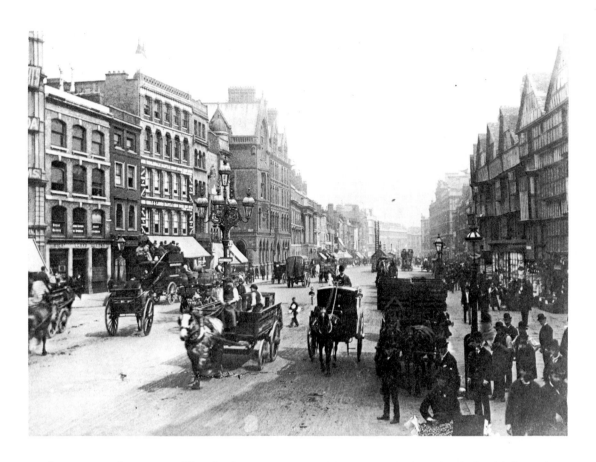

3 In town and country alike the horse was the forerunner of the motor car as the main means of transport. Many differing types of horsedrawn vehicle were available and included heavy delivery carts, the hansom cab, the lighter two-wheeled 'personnel carrier', a horsedrawn double-decker bus and the familiar brewer's dray loaded with barrels—a reminder of the days when beer really did come from the wood. All these vehicles were eventually to be superseded by motor transport but they were common enough in Holborn Bars in London in 1889.

4 (right) On the farm the traction engine was being developed as a heavy workhorse. Specially built engines were in common use for ploughing, whilst the threshing contractor quickly converted to steam to speed up his work. The first agricultural engines were simply boilers with the driving mechanism mounted on top and were drawn from place to place by horses. It was soon realised, however, that steam could also serve as motive power and so the traction engine came into being. This engine could have been photographed at any time between 1865 and 1903, but its most probable date is 1885. The engine is thought to be a Robey and could have been built in Lincoln as early as 1865. Engine and threshing drum await the arrival of the crew to start work on the stack.

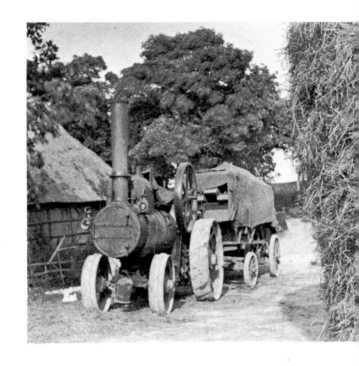

5 (right) Bicycling was a popular hobby with the late Victorians and many were in use for everyday transport in towns and villages. They took the youngsters further afield. The ordinary bicycle, nicknamed the penny-farthing by virtue of its enormous front driving wheel and tiny 'steerer' at the rear, was a feature of the 1870s and 1880s, and it was estimated that in 1876 there were as many as 50,000 on the roads of Britain. The Safety bicycle of the late 1880s brought about its downfall and introduced the wheels of roughly equal diameter that survive on the machine we know today.

A touring club outing stopped at the Angel at Ditton, Surrey, was typically equipped with penny-farthings, safeties and a tandem tricycle.

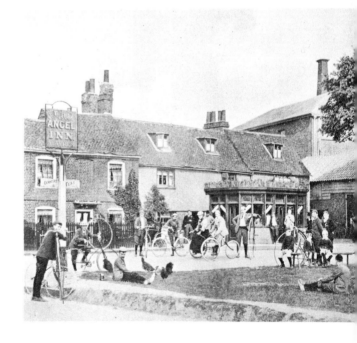

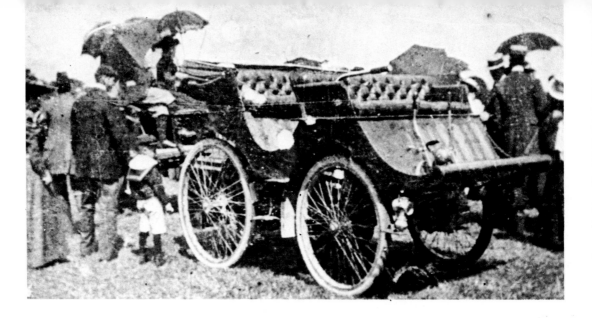

6 (above) The first full-scale four-wheel petrol car of truly British origin was designed by Frederick and George Lanchester in 1894 and completed in 1896. The tubular chassis was remarkably rigid, and from the outset the car was designed to run on pneumatic tyres, which were especially made for the brothers by Dunlop—the first car tyres Dunlop produced. The first run with the car was in late February or early March 1896, without the statutory man walking in front. It is recorded that they met a policeman, but he turned a blind eye. After some six months' running the car was partially redesigned and rebuilt, but it appeared in its original form at Evesham Regatta in 1896, when this photograph was taken.

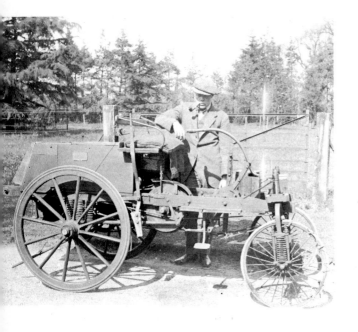

7 (left) In 1868 John Henry Knight of Farnham built his first road vehicle, not altogether an impractical steam carriage. He was to build his first car, a three-wheeler, in 1895 and this is believed to have been the first British-made car to travel on the public highway. In the same year Knight was fined for driving on the road without either a licence or the statutory man walking in front. In 1896 he converted the car to a four-wheeler to improve its stability, and around the turn of the century had relegated the machine to the role of estate hack. He obviously experienced trouble with a front tyre, and secured it with rope, but however crude this car may appear, it did have a primitive form of independent front suspension.

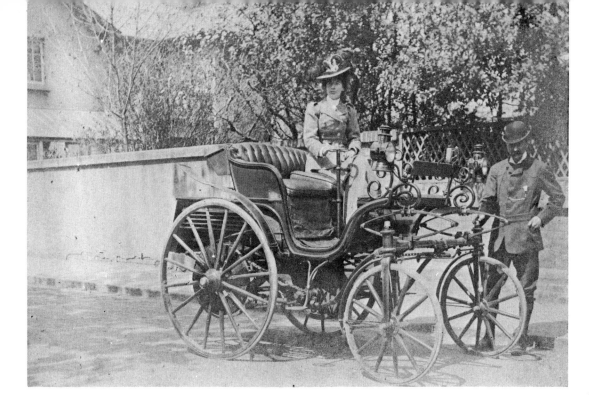

8 The first company formed in Britain to manufacture petrol-driven vehicles was Coventry-Daimler in 1896. The following year their first cars appeared on the roads. Prior to this, apart from the work of a few pioneer experimenters such as Knight, Lanchester and Bremer, all the cars seen on the public highway had come from abroad. The first four importations are believed to have been: a two-cylinder 4hp Panhard-Levassor shipped into Southampton from Le Havre on 11 June 1895 for the Hon. Evelyn Ellis; a 5hp Peugeot that arrived in Southampton about 9 September 1895 for Sir David Salomons; and the arrival in Southampton from Hamburg of a single-cylinder 5hp Lutzmann for J. A. Koosen and a $3\frac{1}{2}$hp Benz for Henry Hewetson on 21 November 1895.

(right) Henry Hewetson with his Benz, 27 November 1895, shortly after collecting it from the docks.

(above) Mr. and Mrs. Koosen with their 5hp Lutzmann. Mr Koosen is reputed to have spent two days at the docks trying to start his car before receiving the advice that it required petrol to make it go.

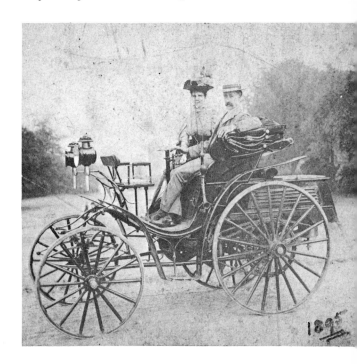

EMANCIPATION RUN 1896 AND THE 1,000 MILE TRIAL 1900

Much has been written about the original Brighton Run of 1896, recorded in history as The Emancipation Run. On Saturday, 14 November 1896, motor cars were allowed for the first time to travel on the public highway without being preceded by a man 'walking in front'. The speed limit was also raised from 4mph to 12mph. Until then all auto-mobilists had been seriously hampered by the law and a number had been prosecuted for offences under it.

The Autocar, Britain's pioneer motoring weekly, regarding these law reforms as a 'red letter day', actually printed its Emancipation Number in red to celebrate. The most important event of the day, however, was a run from London to Brighton organised by the Motor Car Club. In true Victorian splendour it started with a ceremonial breakfast in London, followed by lunch at Reigate and a grand dinner at Brighton. Some thirty-three cars took part, and according to most accounts thirteen finished within the specified time; another nine arrived very late but then the road conditions were described as muddy.

It is amazing that for an event as import-ant as this very few photographs appear to have survived. *The Autocar* had photographers along the route, but most of the pictures were poor and only those taken the next day by Argent Archer, with cars positioned and personalities posed outside the Hotel Metro-pole in Brighton, have any quality. A family snapshot album kept by A. Barton-Kent contained previously unpublished pictures of the Run; although of poor quality, they are included here for their rarity.

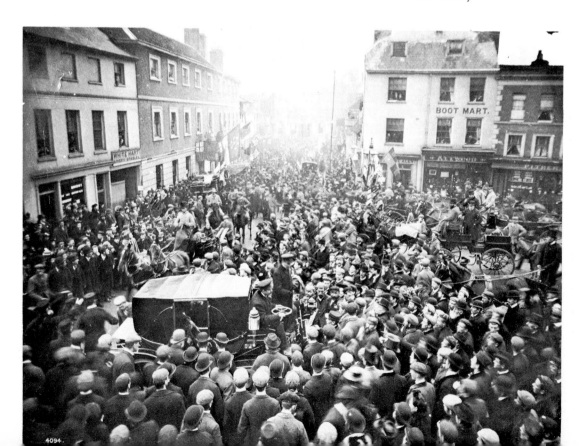

11 (opposite) Reigate was chaotic as spectators, leaving only a narrow strip of roadway, crowded in on the cars. Locked in this frantic scene was the Cannstatt Daimler of F. R. Simms, co-driven by J. Van Toll, and Gottlieb Daimler himself was an honoured passenger. This vehicle carried a proud slogan, Present Times, painted on its sides and across the rear; it was the first motor car to take part in the Lord Mayor's Procession in London.

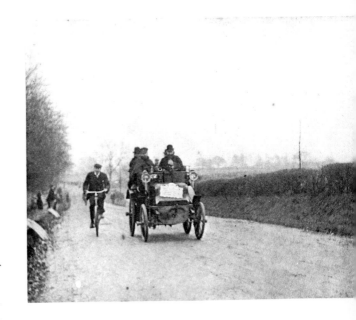

12 (right) Very little was written in the contemporary Press about the two American Duryea cars entered for the Run. *The Autocar* and the Press credited the first arrival at Brighton to a Bollée car, but Mr Thrupp, a passenger in one of the Duryeas, in a letter to *The Autocar* published on 28 November 1896, claims in a sworn statement before a commissioner of oaths that it was the Duryea which arrived first. Mr Barton-Kent noted the Duryea as being the first to pass his vantage point and Duryea claimed in his American advertising that he was first in the British Liberty Run of 1896.

Barton-Kent also revealed the sparsity of spectators on the open road and the apparent ability of cyclists to keep up with the motor cars—on up-grades at any rate. The car shown here is a Daimler Waggonette, in fact a Panhard, which belonged to the Great Horseless Carriage Company. It had previously finished second in the Paris–Marseilles–Paris race. One of the passengers was the Earl of Winchilsea and in his speech at the final dinner he said: 'I have come down on a car, and had the most delightful ride. There was no smell or vibration and the vehicle was under perfect and extraordinary control.' Surely he must have been exaggerating!

13 (right) Crowds there certainly were along the roadside awaiting the arrival of the cars, as Barton-Kent depicts. In modern times the Brighton Run is thought to attract as many as half a million watchers over the fifty-three mile route. Most now come by car but in 1896 they only had bicycles or horse-drawn vehicles. Others came on foot, many dressed in their Sunday best.

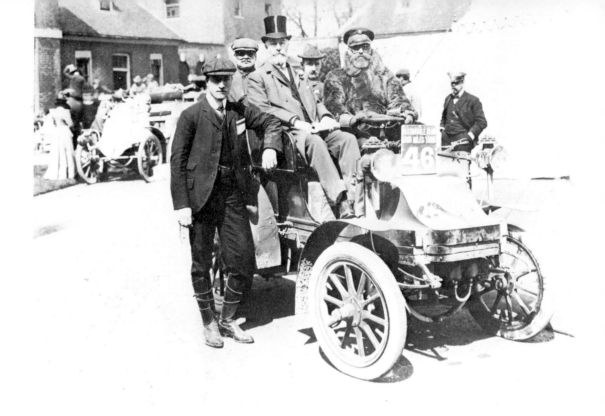

14 The Emancipation Run of 1896 was the first major road event for automobiles in Britain and although a number of meets and other social functions were held during the next three years, it was not until 1900 that another major rally was staged. By this time the motor vehicle was becoming established, a native motor industry was in evidence and many cars were being imported.

The Automobile Club of Great Britain and Ireland organised a Round-Britain 1,000 Mile Reliability Trial between 23 April and 12 May 1900. The purpose of the event was to convince the public that the motor car was reliable enough to be used for long distance travel. The published programme was a veritable 'buyers' guide' and the event was promoted with all the professionalism so sadly lacking in the chaos of the Emancipation Run. Sixty-five vehicles started, although many more were entered, and forty-nine finished, but almost half the competitors had completed the course without serious penalty. The event started with a seven-day show at the Agricultural Hall at Islington and at various points along the route one-day exhibitions were staged which attracted thousands of visitors. It was this event more than any other that really put British motoring on the map.

Breakfast on the first day of the trial was held at Calcot Park, Reading, 'Mr Alfred Harmsworth's country residence'. This car is a French Georges-Richard entered by the British agents, the Automobile Manufacturing Company Ltd. The Mayor of Reading is seen seated alongside the driver who is wearing one of those fur motoring coats so necessary for a mammoth drive of this sort. Standing beside the car is Walter Bersey, who had run a none-too-successful fleet of electric taxi cabs in London in 1897 and 1898.

15 (below) Gale-force winds were to greet competitors on the 121 mile stage of the Trial between Edinburgh and Newcastle Upon Tyne on Friday May 4. Preparing to leave Edinburgh, the Georges-Richard is about to be started by handle, and A7 is the Parisian Daimler owned by Alfred Harmsworth. It was at his home that breakfast was taken on the first day. Mr Harmsworth was proprietor of the *Daily Mail*, and another competitor, the Hon John Scott-Montagu, was that paper's motoring correspondent. It is not surprising, therefore, that the *Daily Mail* gave good coverage to the event, even if Harmsworth was later to combine personal enthusiasm for the automobile with a 'knocking' policy in his papers angering many of his fellow motorists.

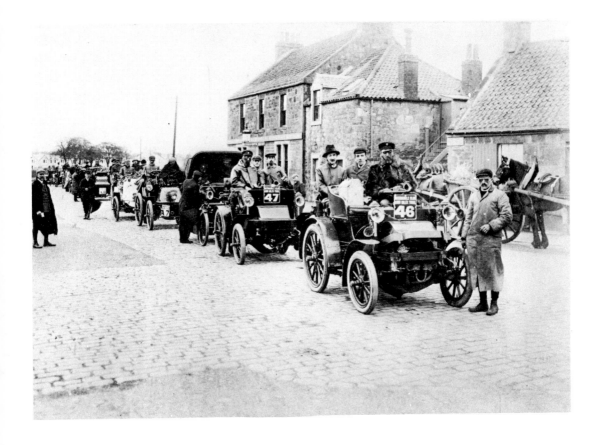

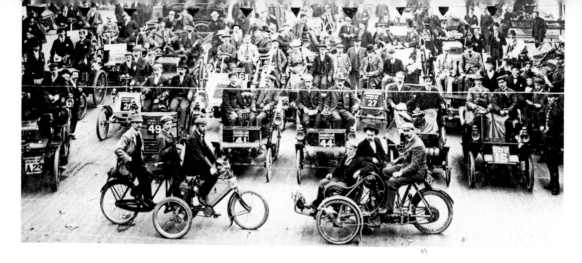

16 (above) Whilst in Sheffield the vehicles were exhibited for one day in the Norfolk Drill Hall. Contestants gather prior to the opening. In the right foreground is a Century Tandem Tricycle which joined the event at Coventry and in the left foreground, an Ariel Tricycle with pedal assistance for the rider on uphill grades and a Whippet detachable trailer often referred to as a ladies' attachment. The profits from this particular exhibition went to the Transvaal War Fund.

17 (below) One of the successful, finishing with a 'clean sheet', was Mrs Bazalgette on her own 3hp Benz Ideal. Only four lady contestants entered and drove throughout, a remarkable feat of endurance because the weather was anything but clement.

The Autocar reported: 'A lady spectator at the Manchester show was overheard to say while looking at the exhibited and innocent automobiles, "Oh, yes, they are terribly dangerous, and travel so fast they ought to be fitted with cow catchers." The lady was very stout!'

CARS AND COACHBUILDING

18 (below) In the pioneering days of motoring there were experiments with all forms of motive power for vehicles. One of the most unusual was the Dunkley, a vehicle powered by compressed coal gas. Dunkley was first and foremost a maker of prams, although in 1896, the year of this car's debut, his shop proclaimed that he sold 'Horseless carriages, typewriters, phonographs, cycles and Dunkambulators.' By 1901 the Dunkley coal gas car had become more conventional in appearance, with driver and passenger no longer vying with each other for control. Mr Dunkley's theory was that 'coal gas stations' could be set up along any street and the car plugged in for recharge on battery-electric principles. In the early 1920s, Dunkley was still making outlandish devices; a clip-on motor for his prams, for example. As motorised vehicles were not allowed on the pavement, this meant that nannies had to Pramotor in the road. Dunkley's Pramotor, like his coal gas car, did not succeed.

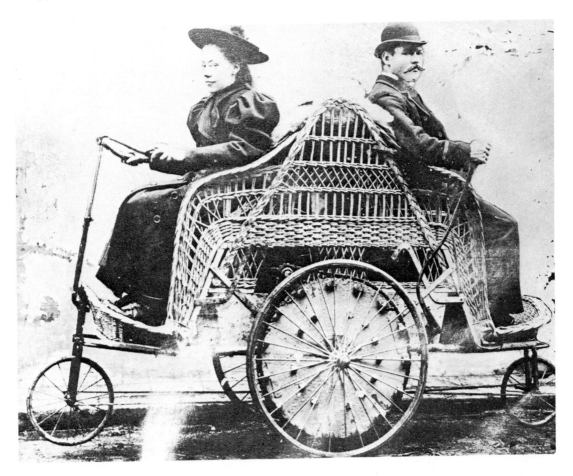

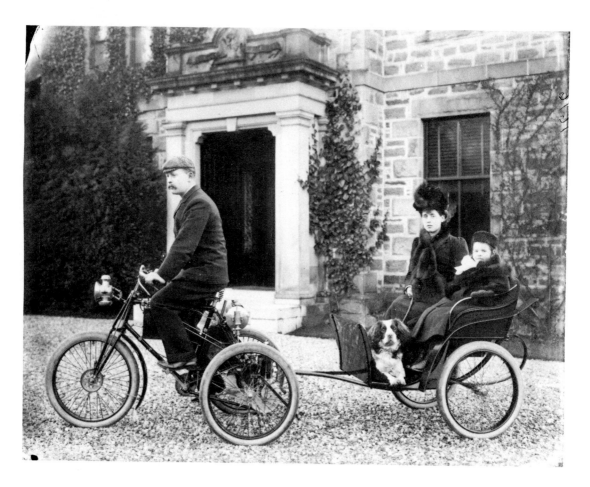

19 (above) The motor tricycle is as old as the car, and the pioneers of this type of machine were de Dion-Bouton in France. These tricycles were simple enough to be ridden by a woman and as they developed over the years and the horse-power increased, various trailers (often known as ladies' attachments) were marketed. This de Dion-Bouton tricycle of 1898 is equipped with the minimum of extras—only a small acetylene bicycle-type headlamp and no rear mud-guards. It must have been most uncomfortable to travel in the trailer with exhaust fumes from the engine and mud from the rear wheels coming straight back at you, even if there were three wheels and a frame which lay between you and an accident. The pedals were used for starting the machine and for giving light assistance up hills.

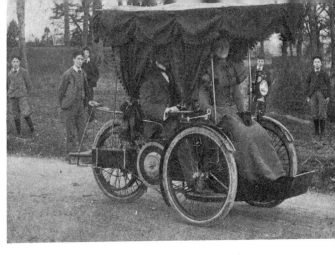

20 (right) In 1895 Léon Bollée, previously a designer of steam road vehicles in France, turned his hand to making motor vehicles and his first design was a tandem two-seater three-wheeler with a powerful 3hp motor. These three-wheelers were first copied in Britain by the Coventry Motor Company in 1897 and called Coventry Motettes. Originally, they were completely open but in 1898 a canopy was introduced for the protection of driver and passenger. The remedy, however, proved worse than the complaint and was soon discarded in favour of rainproof clothing for the occupants. This rainhood, the design of an undertaker, can be better imagined than described when wet with half a gale blowing. The fitting was known as a de luxe extra. The passenger sat in front, which saved her from the exhaust fumes and self-detaching propensities of the trailer, but made her more accident-prone.

21 (below) For the keen motorist who could not afford a car and who wanted more than two wheels, there was always the tricar. Suitable as they appear to be for the small family, most of these machines were very crude. The passenger is very vulnerable to accident. This is a Singer 6hp of 1907, fitted with a coachbuilt forecarriage and protective apron. The Singer was very much a de luxe machine and had a water-cooled engine. It would have a top speed of 45mph. The controls are those of a car rather than a motorcycle. Whilst most tricars were selling for under £100, this one cost £110. A cheap small car would have sold for one-and-a-half times the price. In 1903 de Dions cost £200, but all manner of single-cylinder nastinesses were yours for £150 in 1907. The 6hp Rover cost 105 guineas but you had very little for the price.

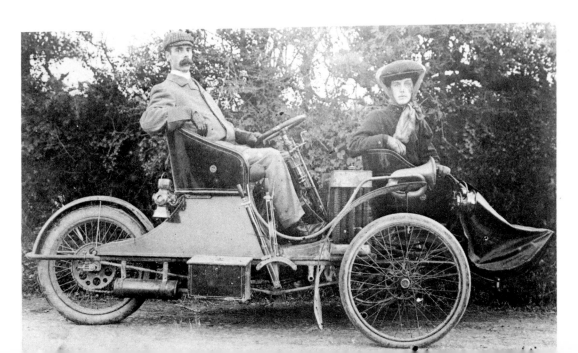

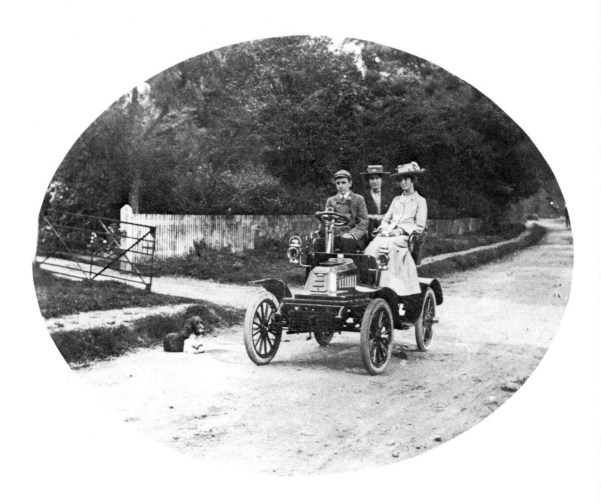

22 The de Dion-Bouton 6hp Model Q was a car much fancied by commercial travellers and doctors. It was a very typical run-about of the early days of popular motoring, and cost £200. The makers even produced a sixty-two page catalogue in 1906 entitled *Motor Carriages for Medical Men*. At one time the French firm of de Dion led the field in exporting cars to England and consequently more de Dion-Boutons survive in Britain than any other make of veteran car. Up until 1906 France was the largest car manufacturer, maintaining her lead in the export trade until 1913. Peak production at de Dion reached nearly two hundred cars a month.

23 Proud owner of a Gardner-Serpollet steam car poses outside the photographic studio of A. G. Rider in Winchester. Built in Paris until 1907, the Serpollet never earned the popularity of the more simple Stanley steam cars and the firm folded with Léon Serpollet's death. The steam car was a complicated machine, and servicing by unskilled motor engineers tended to be agricultural, which contributed to the brevity of its life. The large shield over the rear-mounted boiler deflected the heat away from rear-seat passengers. Steam cars had their greatest popularity in America and the Stanley Company was still turning out as many as 650 cars a year in the early 1920s.

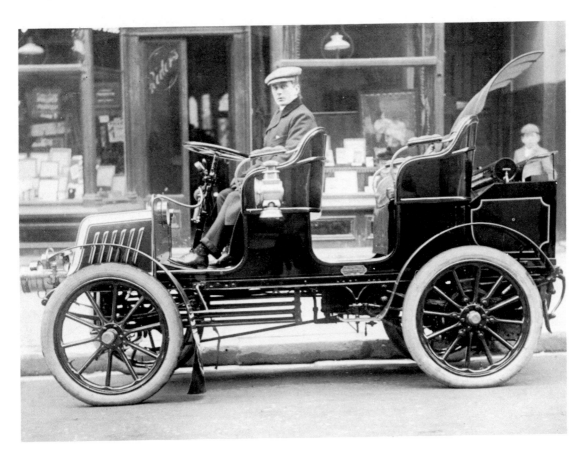

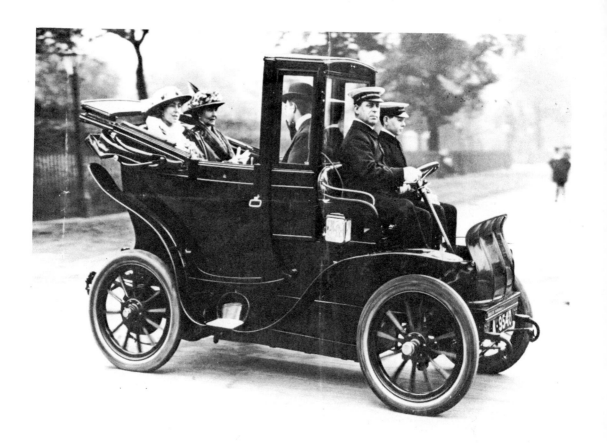

24 Between 1896 and 1939 several hundred different makes of electric cars were listed. Many of these ventures quickly folded, although the electric car stayed in relatively popular use, mainly in the USA, until 1914. It was ideal as a town carriage, and more than any other form of car retained unashamedly the lines of horsedrawn vehicles. Its range was little over fifty miles between charges. The headache was the same then as it is now: no battery was small enough whilst allowing a sufficient radius of operation. This brougham by the Electromobile Company of London could have been let out on contract hire for a fee of £325 a year, a sum which covered all charging and repairs though not the cost of the driver. In this case the chauffeur wears a naval-type uniform and is accompanied by a young footman.

25 One of the most elegant cars offered for sale in the earlier years of motoring was a James and Browne. This model appeared in 1905 and looks absolutely ideal as a ladies' runabout, rather as the Mini might be today. The engine is mounted amidships under the floor of the car, which explains the position of the starting handle on the offside. One of the most difficult aspects of motoring from the ladies' veiwpoint was starting the car by hand. The first electric self-starter was a home-made device fitted by a Mr Dowsing on his Arnold-Benz in 1896. In October 1900, Mr Fred Horne of Blackheath, writing in *The Autocar*, described a 'modern' type self-starter which he had had fitted to his Daimler. However, the first manufacturer actually to fit an electric starter as standard equipment was Cadillac as late as 1912. Compressed air had also been used as a starting device on cars such as the Winton, Delaunay-Belleville and Wolseley. James and Browne offered a mechanical starter consisting of a pull-up lever operating on the crankshaft end.

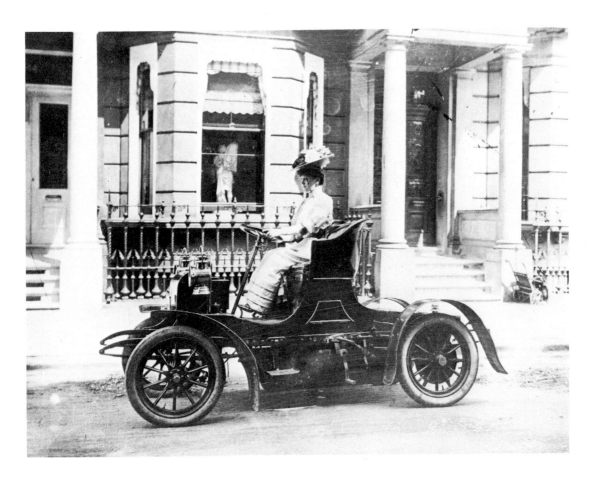

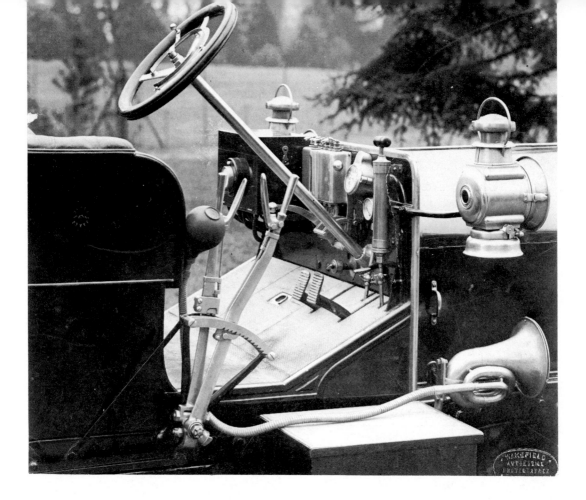

26 Blowing the horn by accident whilst changing gear was a hazard to drivers of the 1903 Mercédès. The box on the left of the controls houses the trembler coils for the auxiliary ignition and next to it are the small brass oil tank and engine oilers. Below this tank are visual oil drip feeds, controlled by the knobs on top of the tank, which allow the driver to ensure that oil is being delivered to the different parts of the engine. The two levers alongside, looking as if they come from a signal-box, most probably operate a clutch stop for cold starting and a hand throttle.

The clock is probably an extra but the pump and gauge most certainly are not. Fuel flows from the rear-mounted petrol tank by exhaust pressure and the first job for the driver is to hand-pump the air pressure until some 2 to 3lb show on the gauge. Floor pedals are conventional, although the foot-brake operates on the transmission and should only be used in an emergency; all other braking should be done on the outside handbrake, which works on the rear wheels only. There are no front wheel brakes. The accelerator projects through the scuttle and the handbrake is the outer of the two main levers by the seat, the other being the gear lever. The centre boss of the steering-wheel contains an advance and retard control for the ignition. The headlamps are no doubt acetylene but the sidelamps are oil.

27 No one could call the 1908 20hp Lanchester a beautiful car but it did contain some very advanced engineering ideas. The engine was housed between the front seats—hence the lack of bonnet. As far back as 1901, Frederick Lanchester's cars were fitted with pre-selector gear-boxes, followed in 1903 by disc brakes and in 1904 by full pressure lubrication. Despite these innovations, however, the 1908 car still had tiller steering instead of the more normal steering-wheel. This Lanchester's windscreen was fitted with an early type of safety glass, incorporating wire netting to prevent splinters flying in an accident, but it was not until 1937 that safety glass became compulsory on motor vehicles. The cog on the inside of the offside wheel drives the speedometer, an extra which did not become compulsory equipment in Britain until 1927.

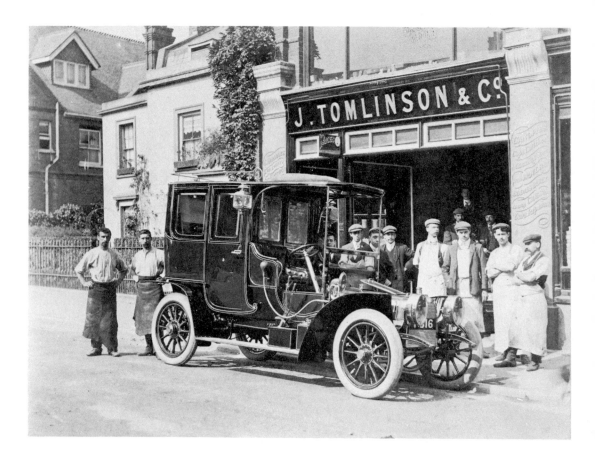

28 With the coming of the motor car, the enterprising country coachbuilder started making bodies for the new vehicles. Photographed about 1906, this is a newly bodied Talbot outside the coachbuilder's premises prior to delivery. In the days of the bespoke body, it was usual for the maker to have it photographed so that he had a good album of his work to show future potential customers. A small firm would only build a few bodies and so the photographer would often be asked to include all the workers in the picture. Beautifully equipped, the Talbot has acetylene lamps at the front fed from a generator on the running-board, and oil-fed carriage lamps on the side. Obviously designed to be chauffeur-driven, the car has a speaking tube from the rear compartment.

29 Bespoke coachbuilding at its best, a Panhard Levassor of 1906, on a moderately expensive chassis. The coachwork is by Barker and Co who had been making bodies for horsedrawn vehicles since 1710 and readily converted to the motor car's needs at the turn of the century. This photograph was taken as a sample to attract further custom. The landaulette body is finished in a striped colour scheme, a favourite style of contemporary coachpainting, and luggage is carried in the open on the roof of the chauffeur's compartment. The driver has been provided with a windscreen but the absence of doors and side-curtains at the front is a legacy from horsedrawn days.

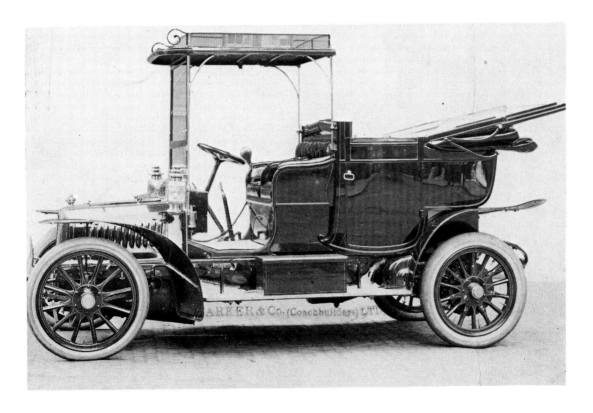

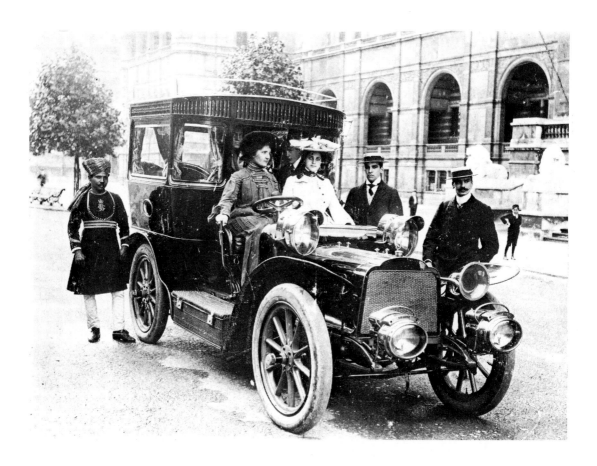

30 A publicity picture taken in 1903 announces the sale to the Marquess of Anglesey of one of the most luxurious cars yet made. The car was a 1903 40hp Mors with special bodywork by Lamplough et Cie of Paris made to a design sold to them by Montague Grahame-White. The car won the highest award for coachwork at the Paris Show and five orders were taken. Grahame-White purchased the car after the show and sold it to the marquess for £2,500. The woodwork was of polished mahogany, the windows had spring sun-blinds and there were four revolving armchairs upholstered in dark red Morocco leather. The interior was electrically lit and there was a heating apparatus for winter driving. The ceiling was decorated in Louis XV style; there were royal-blue plush curtains to the windows and the floor was covered in crimson Wilton carpet. A telephone installation enabled the occupants to give directions to the chauffeur. All the interior fittings and furnishings were supplied by Maple and Company.

31 A luxurious six-wheeled Pullman car, built on a special 40hp de Dietrich chassis. It was designed and tested by Turcat-Méry at Marseilles in 1906, was offered by Lorraine-Dietrich as a catalogued type and was first seen in London in November' 1907. It is doubtful whether the car went into serious production. Drive was taken to the centre wheels, the rear wheels only taking weight, but the interior of the car was very luxurious, with seats that folded flat to form two beds. There was even a small washroom built into the rear behind the seats, accessible from inside the car as well as via a back door. Special attention had been given to the springing, and shock-absorbers gave the smoothest possible ride. Despite all the luxury, little thought had been given to the chauffeur who undoubtedly had to drive long distances whilst his master slept at the back; he did have a roof but no doors, windscreen or side curtains.

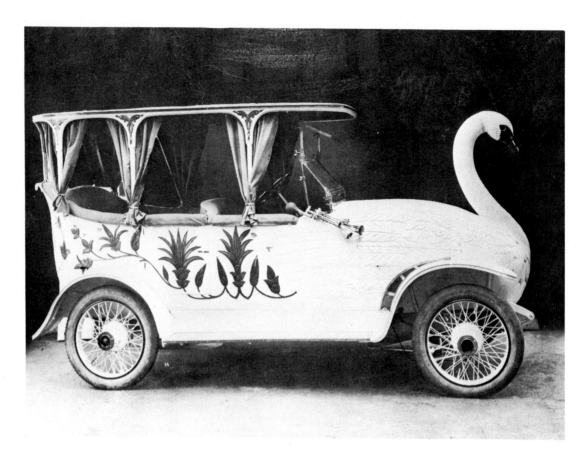

32 Built to the whim of an Indian business-man, this Swan car must have had one of the most unusual bodies ever fitted on an auto-mobile. It was built in 1910 by J. W. Brooke of Lowestoft, better known for their marine engines than their cars. The bonnet is re-placed by the figure-head of a gigantic swan, rather reminiscent of *Lohengrin*. This swan, however, had tricks unequalled by its Wag-nerian counterpart; the eyes were electrically lit and the exhaust gases passed from the silencer out through the beak to produce a swan-like hissing sound. With very little space available for the intake of cool air, the swan was probably most often seen arising from·a cloud of steam vapour. The multi-tone horn appears to have been added as an after-thought and seems incongruous.

33 The epitome of the Edwardian sports car was the 1914 Alfonso-Hispano-Suiza, named after King Alfonso XIII of Spain, an enthusiastic motorist and one of the Barcelona firm's most loyal customers. A sports car is possibly the most difficult of all motoring terms to define. W. O. Bentley once said, although this was not his own opinion: 'To the ordinary person, a sports car has always been a small, open motor, with seats for two and a noisy exhaust, which is unbearably uncomfortable for more than the shortest run and probably often goes wrong.'

This may have been partly true of some sports cars of the 1920s and later, but earlier sports cars were usually tuned and lightened versions of high-powered touring cars. It was not until the coming of such vehicles as the Hispano-Suizà and its contemporaries, the 'Prince Henry' Austro-Daimler and Vauxhall, that we had true production sporting machines. They were specially designed, high-performance cars on which speed and good road holding went hand in hand with comfort and reliability. They were fully upholstered, often seated four, and had reasonable weather protection. Cars such as these could be entered for sporting events like the hill climbs at Shelsley Walsh, and stood a good chance of success. The Hispano was popular when petrol was rationed in World War I: it did 25mpg without difficulty.

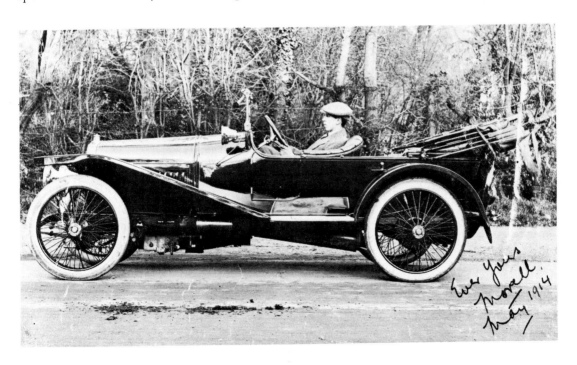

THE FAMILY CAR AND MOTORING FASHIONS

34 'The Old and the New', the simple caption to this postcard, presumably refers as much to the vehicles as to their occupants. The 1899 Benz has an early Hampshire registration number, which dates the picture at 1904 or later. It was in 1904 that all motor cars were required to be registered and carry number plates. The gentlemen in the car use a driving rug, very typical of the time, to keep their legs warm. The tricyclist, believed to be the local doctor, has no need for such protection, being kept warm by his own exertions.

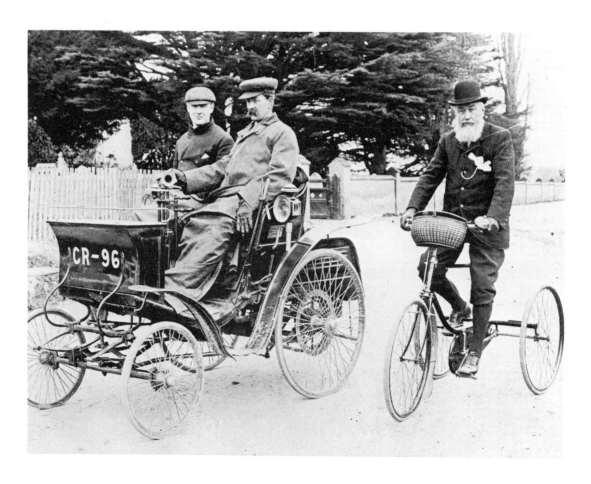

35 (above) Mr C. Sadler of Chiddingfold with his first motor car, a Decauville Voiturelle of 1899. A French import, the Decauville was unusual in having independent front suspension by transverse front spring and sliding pillars. The Decauville was the first production car with this feature but sophisti-cation went no further, for the rear wheels were totally unsprung. Steering was by bar, and lamps were extras. The 5hp twin-cylinder engine was mounted in the rear of the car and was water-cooled. The lightweight wire wheels were of bicycle-type and non-detachable.

36 (right) The proud owners of a recently imported American Curved Dash Oldsmobile pose outside their house whilst the gardener/handyman looks on; maybe he was the chauffeur as well since Oldsmobile's slogan was 'Nothing To Watch But The Road', and the car was almost foolproof. This model was the world's first mass-production motor car, 2,100 being sold in 1902, the year the photograph was taken. The 1.6 litre single-cylinder engine is fitted with a very large silencer and as the top speed of about 18mph was achieved at a mere 500rpm, 'one chug per telegraph pole' was particularly appropriate.

37 (above) Posed the photograph may be, but nothing could be more typical than this scene at Norton in Suffolk, taken around 1905. The local shop and post office was the focal point of trade in the country village. You could buy haberdashery and hats on one side, and food, tins, tonic and postal requisites on the other. Callers came on foot or by pony and trap; and later by motor car. The 1902 5hp Peugeot was an inexpensive runabout and one of the de Dion-Bouton's rivals. Presumably the lad in the driving seat was only posing because the Motor Car Act of 1903 stipulated seventeen as the earliest age for car driving, even if fourteen-year-olds were let loose on motor cycles.

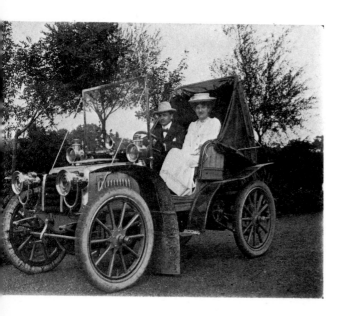

38 (left) The Hon Charles Rolls was a pioneer motorist in Britain and the only gold-medal winner in the 1,000 Mile Trial; prior to teaming up with Frederick Henry Royce in 1904, he was an importer of Panhard-Levassor cars from France. Here, Rolls drives a 1902 Panhard. The hood is partially erected in a *de-ville* position, which gives some shelter from the elements but is intended mainly as a protection against road dust. Also desirable in the days of unmetalled road surfaces were the huge front mudguards, as fitted to contemporary long-distance racing cars. The cane-work panelling on the rear part of the bodywork is an eccentricity of the period.

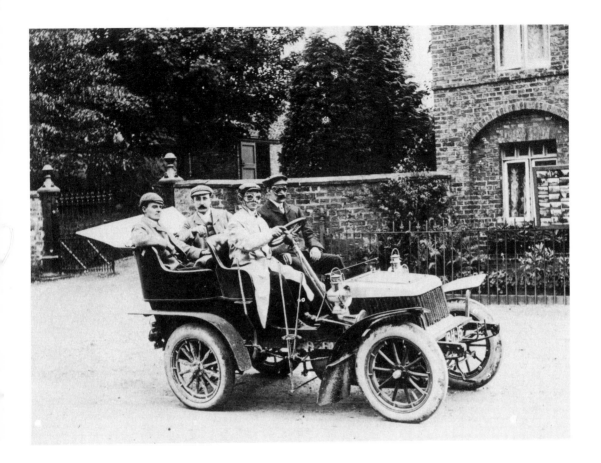

39 Dust was one of the worst hazards for the early motorist. Many experiments were undertaken by manufacturers to prevent dust penetrating into the car and the Automobile Club staged several dust trials. The driver and front seat passenger of an Argyll car of Scottish manufacture built in 1903 wore goggles and face masks for protection. The rear-seat passengers, whilst scorning goggles, were partly protected by a specially erected shield astern to stop the dust billowing into the car from the back.

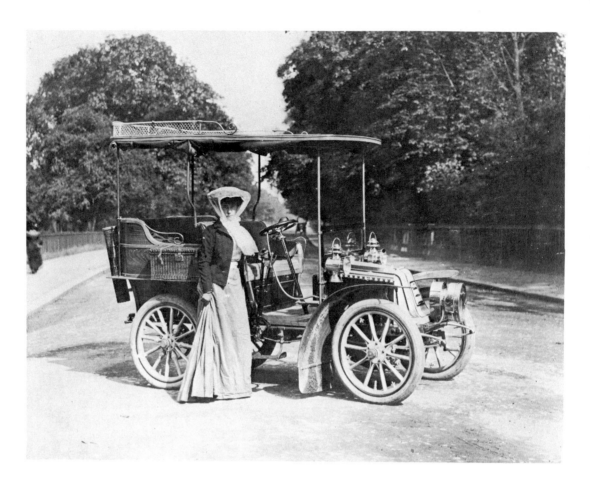

40 Frank Hedges Butler gave his daughter, Mrs Vera Nicholl, a 1903 Renault as a wedding present. Mrs Nicholl was a keen lady motorist and wrote an early article on Renault care and maintenance. Her heavy motoring skirt and coat and securely fastened hat were essential protection from the elements since the half-windscreen is scarcely adequate. The small Renault was a popular car with functional bodywork, an umbrella (or parasol) basket at the rear and picnic hampers on the mudguards. The car was fitted with side curtains all round, but when in use they effectively blocked all but forward vision. The lady was obviously contemplating night driving, as a huge acetylene headlamp has been fitted.

41 (right) This French-built Ader was obviously a well-loved and faithful friend of the family. It was first introduced into Britain in 1901 but this car is a 1902 model. Possibly bought by the owner at second- or third-hand, it would appear to have been well used and the crude repairs to the front tyre suggest that the family was a little hard-up—or maybe be a long way from a garage. Behind the front seats are two side-mounted, inward-facing occasionals, but even those were not to be sufficient for this family.

42 (right) The 1908 Humber provides a good example of the shape of the average touring car during the mid-Edwardian period. Despite the raindrops on the bonnet and windscreen, the family were determined to go motoring with the hood down. Since the windscreen did not offer protection for rear-seat passengers, the ladies' hats were secured with scarves and one had a veil.

The spare 'wheel' was a patent device called a Stepney. If a puncture occurred, rather than mend it or change the wheel, the car was jacked up and the Stepney fixed alongside the punctured tyre. The journey was continued with a double wheel. To stop excessive vibration and give better support to the windscreen when the hood was erected, two supports linked the windscreen to the mudguard stays.

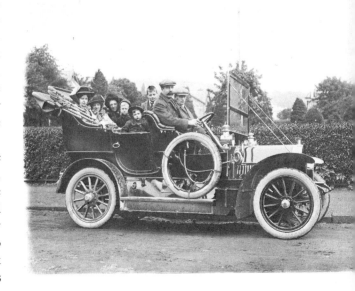

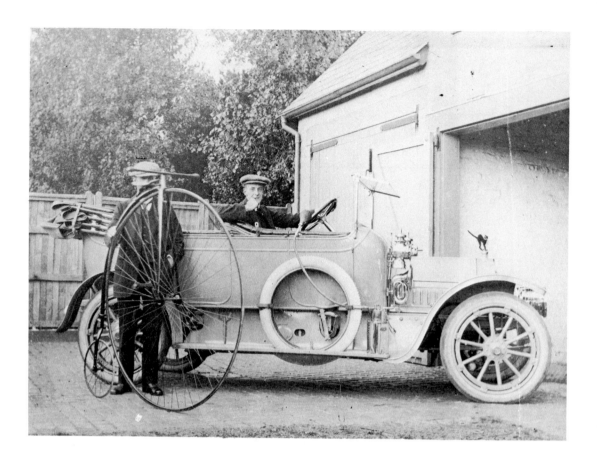

43　The old and the new as they were about 1908. The penny-farthing had probably been resurrected from the back of the garage especially for the photograph, as it had been out of general use for over twenty years. This car's mascot was a lucky black cat but the first car mascot was reputed to have been that made in 1899 for the second Lord Montagu of Beaulieu. It was a figure of St Christopher, and appeared first on the 1899 Daimler which he drove in the 1,000 Mile Trial of 1900. It was designed by Charles Sykes who later made the most famous mascot of all, the Rolls-Royce's 'Spirit of Ecstasy'. Many mail-order firms offered mascots to motorists, in the shape of such unlikely items as swastikas, fat policemen, elephants, monoplanes, the skull and crossbones, and bluebirds.

44 The Mors car was an import from France and its creator, Emile Mors, was an electrical engineer of great repute. The passenger in this car is Magnus Volk, the originator of the electric railway on Brighton beach, who made an experimental electric dogcart which he ran for a short time in Brighton prior to 1897. In order to provide some extra protection for rear-seat passengers, many manufacturers offered a collapsible second screen, seen here in the erected position. This made life easier for those in the back, who no longer had to attire themselves in the style of pantomime bears.

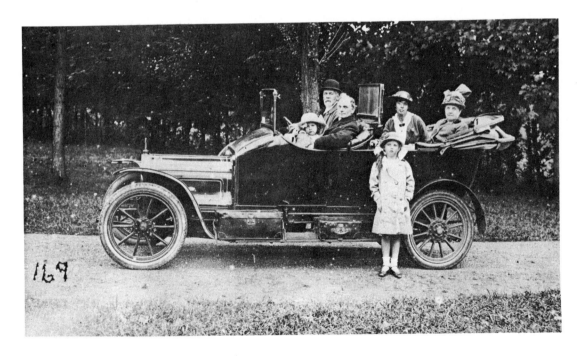

45 (right) The diminutive AC Sociable, ideal for a 1914 Lincolnshire country parson. The 5/6hp three-wheeler was first produced by Autocars and Accessories Ltd of Thames Ditton (later Autocarriers Ltd and then AC Cars Ltd) and developed from a three-wheeled delivery van. The Sociable cost less than £100 and went out of production during World War I. Though the Sociable was delivered with full lighting equipment, the parson has left the lamps in his motor house.

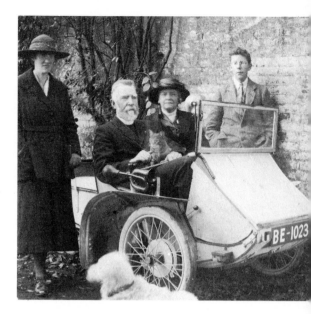

46 (below) The ideal medium-priced car of 1914: a 15.9hp Singer with landaulette coachwork, probably a far better body than the chassis and engine deserved. Electric lighting had yet to replace oil side-lights and acetylene headlamps on medium-priced British cars. The chauffeur now had a windscreen and doors, but no side windows, was separated from the family by a window, and received his instructions via a speaking tube. The ladies still appear to hanker after the open carriage, for even on a dull day they insisted on travelling with the hood down, wearing heavy wind-protecting clothing. It is pleasant to find the chauffeur included in the family snap.

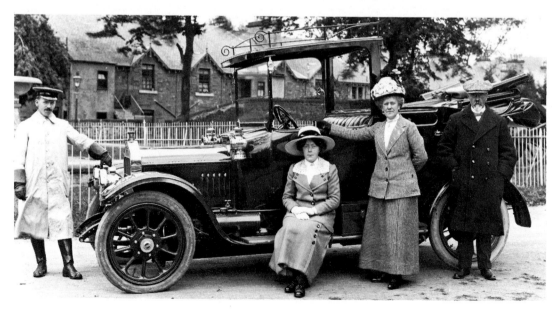

ROADS AND MOTORING SERVICES

47 The art of making a road surface which would successfully take the weight of heavy commercial traffic was speeded up by the adaptation of the steam traction engine to road-rolling work. The very first such machine was a traction engine pulling a separate roller, and this appeared in 1859. In 1868 the first self-propelled steam-roller was built by Thomas Aveling of Rochester, and Aveling and Porter were to produce over 8,000 steam-rollers.

Some rollers were fitted with a scarifier behind the rear wheels, an invention of the late 1890s which enabled the roller also to be used to break up an existing road surface before remaking, a job previously done by hand.

Although the first internal combustion roller was manufactured in 1904, steam-rollers were the staple machinery for road-making up until the 1930s; even now one or two county councils keep the occasional one in reserve for special jobs. A steam lorry brought in the stone, and a horse and cart like that with the Aveling and Porter roller here probably brought coal from a local merchant's yard. Unlike the crews who travelled with agricultural traction engines, the road gangs were usually locally based and returned home each night. The familiar wooden living vans so often seen with a roller would normally be used as sleeping quarters for the driver during the week.

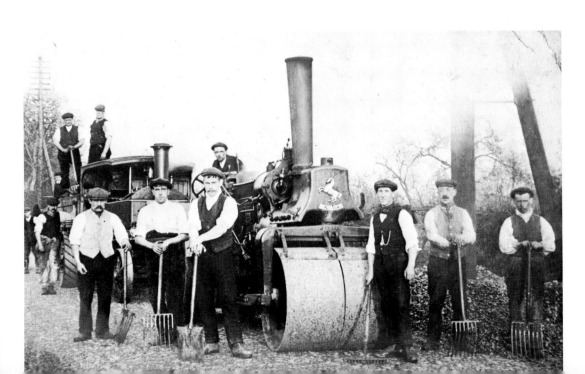

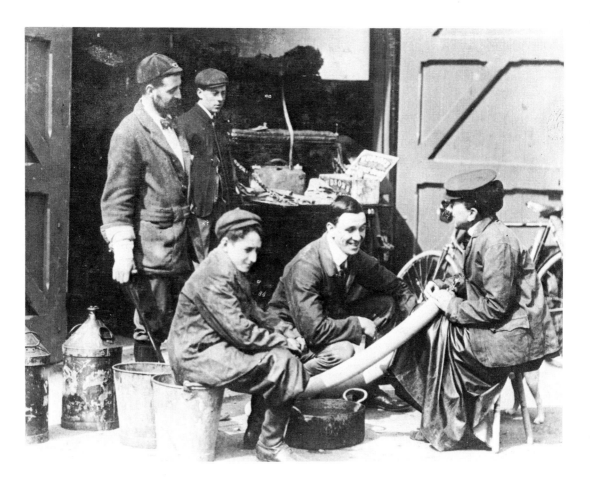

48 One of the greatest problems of the first ten years of motoring was the puncture. The poor road surfaces, liberally laced with flints and hobnails from horses, made punctured tyres a very common occurrence. Mrs. Kennard of Market Harborough, herself a keen motorist, received instructions from her husband's chauffeur on the art of repairing a puncture. The picture is dated July 1899, a time when many motorists still preferred solid tyres.

Solid tyres had been replaced by pneumatics on all but the heaviest and slowest cars by about 1902, but it was not until 1905 that detachable rims or even detachable wheels made their appearance. It took about an hour to remove a tyre from a wheel and substitute a new tube, and much longer if the puncture had to be repaired.

The earliest puncture repairs were carried out with the aid of a 'sticky patch' repair outfit; later came a portable spirit-fired vulcaniser that could be clipped to the running-board. This made for a more durable repair. Tyres were the biggest individual item in a motorist's budget; Alfred Harmsworth, who admittedly ran a large and powerful car, claimed that he spent £500 on tyres in 1901 alone.

49 There were no commercial garages as such in the first few years of motoring. If you did not have a chauffeur/mechanic to repair your car, you had to rely on the local blacksmith or more probably a progressive cycle engineer such as Mr Glover of Witham in Essex. Most towns had their own cycle repairer who in many cases also made his own brand of machine. To the left of this picture two cycles have been crated. The car on the left is an 1898/9 Benz, whilst that on the right is a contemporary Daimler with wheel steering. The advertising was a sign of the times: CTC for the Cyclists' Touring Club cheek by jowl with a tinplate advertisement for Ariel Cycles and Motors. The Ariel Company made tricycles and forecars as well as bicycles from 1898 onwards.

Above the shops is an advertisement for Pratts' Spirit. Petroleum spirit, as it was usually known, was stocked by chemists and motor-orientated shops. The name petrol was registered by Capel, Carless and Leonard in 1896 as a trade name, thus Pratts refer to their product as spirit. The two gallon can, for many years the only means of buying and storing petrol, was introduced by Pratts around 1898.

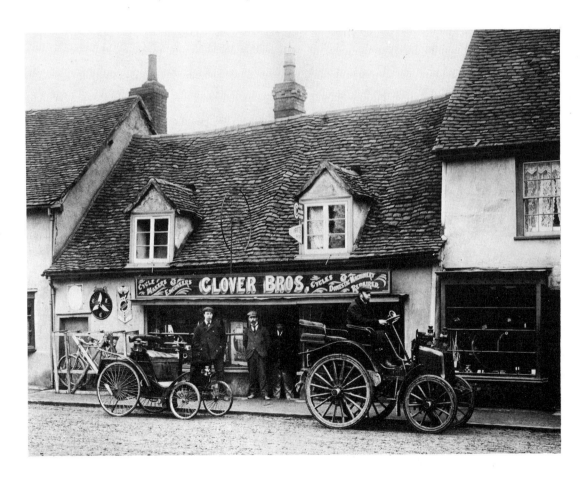

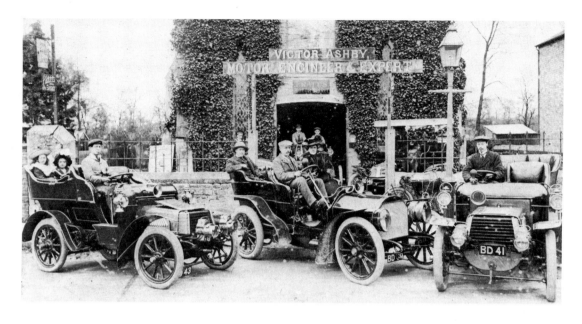

50 (above) The local garage at Towcester in 1906 was housed in a converted chapel. 'Motor Engineer and Expert' might well mean a week's course attended by the local blacksmith. Petrol was still sold in cans; the roadside petrol pump did not become commonplace in Britain until the 1920s. The cars are two Daimlers flanking a Mercédès, with a de Dion-Bouton with surrey top in the background.

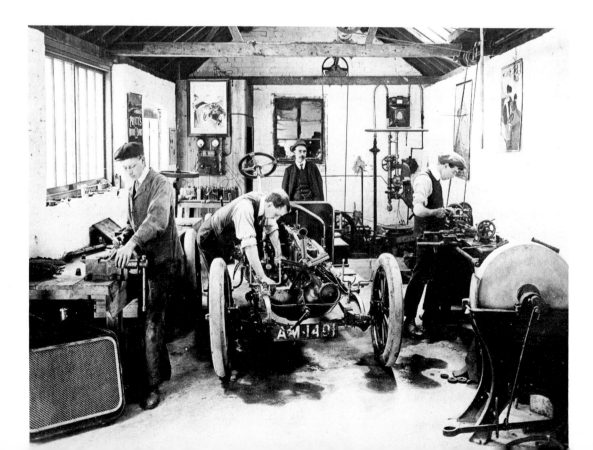

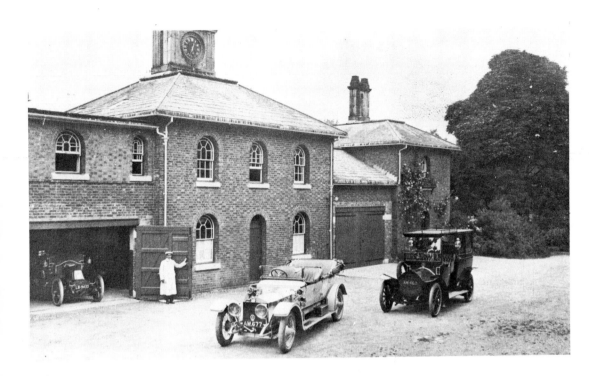

51 (opposite) The Wolseley-Siddeley being operated upon in a country garage of about 1911 was in for a major repair; not only has the radiator been removed but also some of the bodywork. As with the repair of veteran cars today, spare parts were not always obtainable; there were few dealers with large stores departments and new parts had to be made by hand. This workshop was equipped with a stationary gas engine at the back with typical overhead shafting and belting to the lathe. The gas engine was probably newly installed, which explains why the vertical drill was still hand-operated and the grindstone pedal-powered. The battery charger on the rear wall would serve for the small accumulators of the period. Advertisements for oil and spirit adorned the walls.

52 (above) At larger houses the family cars were usually housed in stables which had been converted to take the motor car. The professional chauffeur was often a good mechanic and could undertake all but heavy repairs. In some cases comprehensively equipped workshops would be set up with a qualified engineer in charge, but more often than not, if a high-class luxury car required major repairs, it was driven or railed back to the manufacturers who maintained large service departments.

In 1911 in the stable yard at Pell Mell Hall near Market Drayton, a Mercedes limousine and a Rolls-Royce Silver Ghost open tourer were to be found. They were two of the most expensive cars on the market. In the garage was that faithful stand-by, the Renault; the ageless coal-shovel bonnet makes it impossible to date the car exactly but it could be no older than its stable-mates.

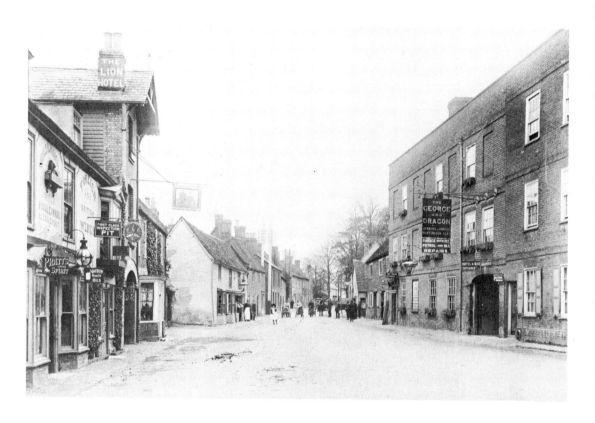

53 Once the motor car began to be used for touring and for business, hotels quickly adapted to the motorist's needs. Whilst the Cyclists' Touring Club sign is still prominent, these two hotels in the High Street at Buckden, Huntingdonshire, vie with each other to attract motoring custom. An inspection pit was an essential adjunct to the hotel garage in order to enable the chauffeur to make overnight adjustments, but often notices would add that use of such a pit was free. In this case both hotels sell petrol, but it would appear that at the time of the photographer's visit in 1906, horses still outnumbered motors.

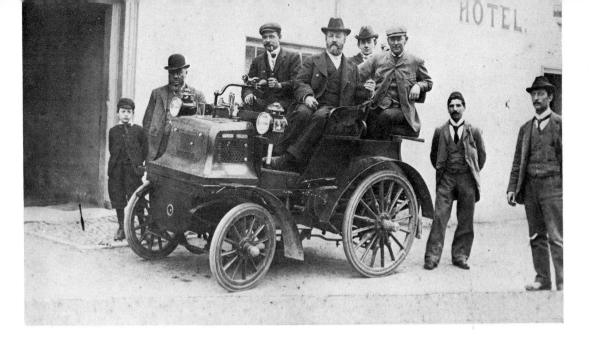

54 The first fatal motor accident in Britain occurred in February 1899 and was caused by the reckless driving of one Edwin Sewell, who had made a name for himself as a fast driver in his Daimler.

(above) Sewell, the year before his fatality, showed off his Daimler outside the Crown Commercial Hotel at Bishops Waltham, Hampshire. He gave the landlord of the hotel (seated rear right), his first-ever motor ride, whilst Mr Pace, a brewer (left, behind bonnet) and the hotel chef (right, behind car) looked on.

(below) Disaster struck whilst Sewell was careering down a steep hill in Harrow, he applied the brakes which were powerful enough to jam the rear wheels, thus pulling the spokes from the rims. The driver and one passenger were thrown from the car and killed. Much was written about this accident in magazines such as *The Autocar*, as it was felt that this type of publicity did nothing to further the automobile's cause in the face of a still relatively hostile public.

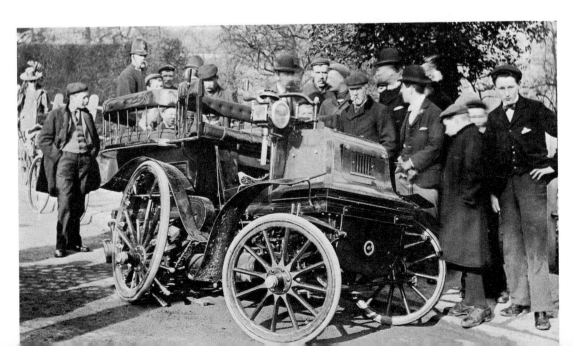

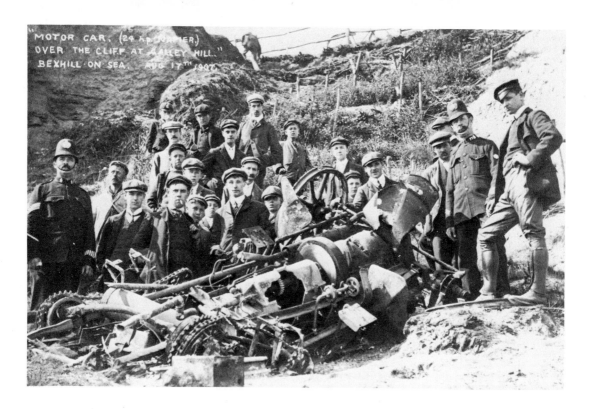

55 It is surprising that there were not more accidents: brakes and suspensions were crude and skidding was commonplace due to the poor road surfaces, poor tyre treads and uneven braking. This accident happened at Bexhill in 1907, when Mr John Lyon's Napier skidded, caught fire and plunged forty feet over a cliff. The driver and passenger jumped clear and were unhurt. The photograph, taken shortly after the accident by an enterprising local photographer, was produced in postcard form for sale whilst the crash was still topical.

56 (above) An extraordinary scene: two cars in collision in an otherwise clear street. The cars themselves are unusual as both are Bentalls, built at Maldon in Essex by a famous firm of agricultural engineers. In seven years of production only a hundred cars were made and so it would seem even more unlikely that the two should choose to make contact. The round radiator was fashionable in the first decade of the century and notable users were Hotchkiss, Delaunay-Belleville and Riley.

57 (right) The driver of this Model T Ford successfully avoided an errant motor cyclist in June 1914, but in turn his car went out of control. It hit a hydrant, plunged through some heavy railings and dropped twenty feet on to Barnes Common, finally stopping against a tree. The car was reputed to be un-damaged save for the bend in the front axle. The cost of lifting the car, towing to a garage and putting it back in running order was less than £5.

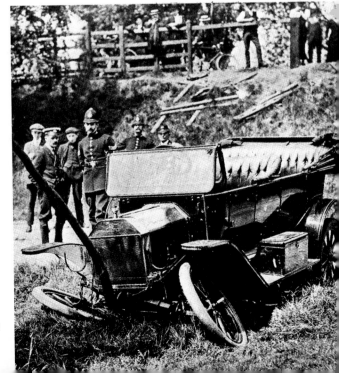

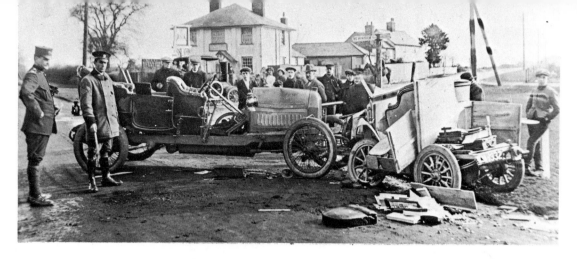

58 (above) There was a fatal accident on the London to Winchester road at Hook in Hampshire on 13 December 1914. The larger car was a 20/30hp Peugeot, whilst the car that was reduced to an almost unrecognisable wreck was probably an AX Renault of 1909. The force of the impact sheared off one front wheel on the Renault and pushed the engine and scuttle back into the front seats. Both the police and the AA are on hand but the photographer has beaten the recovery gang to the scene.

59 (below) If you were unlucky enough to have a breakdown on the road during the early part of the Edwardian period, it was likely that you would be towed either by a horse or, less ignominiously, by another car. As the cars became heavier, so the towing vehicles had to be stronger. If the car was damaged, it was winched up on to the back of a lorry, and a number of firms like Dennis Brothers of Guildford had equipment suitable for the purpose. There were few breakdown vehicles fitted with hoists before World War I but they were developed during that period for retrieving shelled or broken-down vehicles. Many were then sold off on the civilian market and the breakdown lorry, as we know it today, came into being.

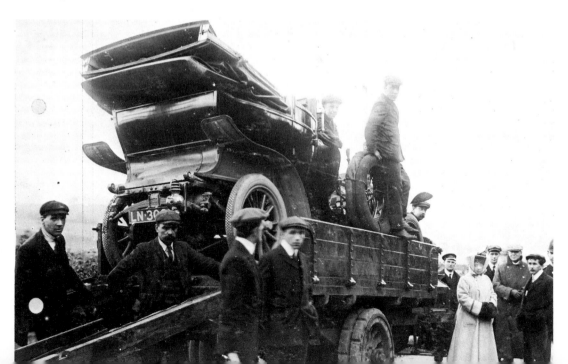

60 (right) 'The Scorcher Held Up', one of a series of semi-comic motoring postcards published in 1903. Right from the first moment that motor cars appeared on British roads, the police were after the drivers for speeding. Between the Emancipation Act of 1896 and the Motor Car Act of January 1904, the speed limit was 12mph. It was raised to 20mph thereafter. Cars were, however, capable of much higher speeds and the police, armed with stop-watches, used to hide in hedges and up trees to trap the unwary motorist.

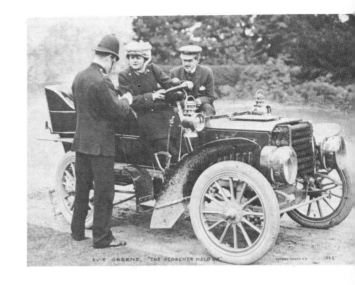

61 (below) It was because of persecution by the police that the AA came into being, starting as a band of scouts who used to warn motorists of speed traps on the Brighton road. The organisation started as the Automobile Mutual Association but quickly changed its name in June 1905 to the Automobile Association. By 1909 it had issued the famous directive to AA members: 'When a patrol does not salute, stop and ask the reason.' In 1912 the roadside patrol boxes were in evidence, although patrolmen were still only equipped with bicycles.

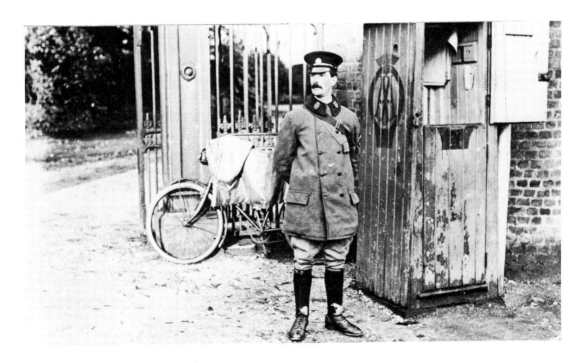

62 (left) Church Street in Preston in 1913 was one of many streets of the time with stone-sett paving. In the wet, it was lethal to cars without special non-skid treads on the tyres. The tramlines did not help either and the 'dreaded sideslip' was a common occurrence. Other treacherous road surfaces encountered in towns were cobbles and wood blocks. A Napier tourer of about 1910 vintage being followed up Church Street by a Sunbeam.

63 (below) Two AA scouts, still with bicycles, meeting for a chat in the main street at Hindhead, Surrey, in 1914. On the left a small Charron was being manoeuvred by a chauffeur; not only large cars were driven by hired hands in those days. In the foreground, the very interesting French importation, the Sizaire-Naudin, a small single-cylinder sporting model of surprising performance, which was popular in Europe until World War I.

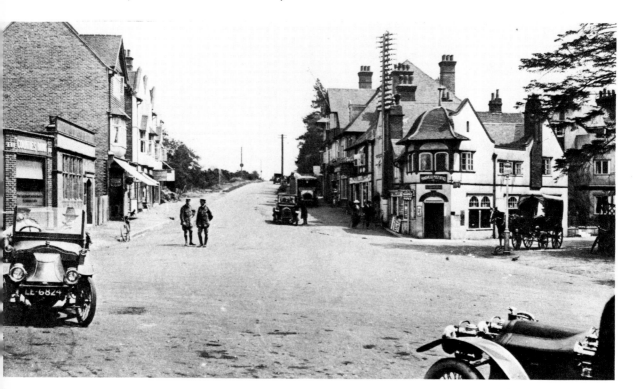

64 (above) Traffic congestion was always a problem in London, even in horsedrawn days. On 18 April 1914 at the Aldgate tram terminus, the street market on the right helped to add to the confusion with the many handcarts in dangerous positions. In the foreground one of the famous General B-type buses attempted to turn right under the eagle eye of a policeman, whilst behind a steam lorry with trailer (most probably a removal van) waited on metal-shod wheels, allowing another B-type bus to squeeze past it and the tram waiting at the terminus. Pedestrians crossed at their peril.

MOTORCYCLING

65 A number of early production motor-cycles were simply bicycles to which motors were attached. Often known as 'clip ons', they anticipated the Cyclemaster and BSA Winged Wheel by half a century. The Swiss Motosacoche (a rough translation of the name would be tool-bag motor) was one of the best, and in the period between 1900 and 1930 the company produced some 200,000 proprietary engines and motorcycles. The firm is still in business, although 1956 saw the last motorcycle leave the factory, and they now concentrate on making engines for industrial and agricultural use. The engine and fuel tank fitted snugly under a cover between the frames, though the driving belt required some ingenuity to give correct alignment. This photograph, taken in 1903, is obviously some form of publicity picture; but why has the photographer left the errand boy and the delivery cart in the frame? Perhaps he had forgotten his white sheet.

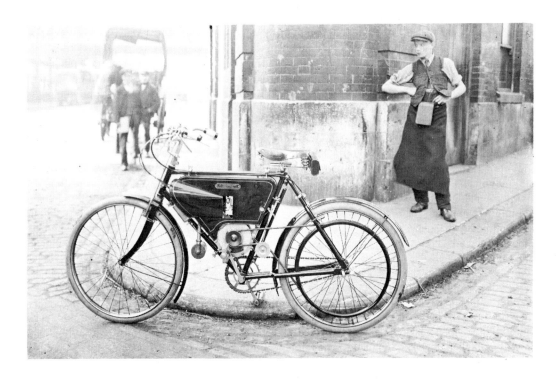

66 Never was the old postcard caption, 'It is Scilly to go further' more true. H. W. Egerton posed on the rocks above Land's End in August 1901 prior to his riding his Werner motorcycle to John O'Groats. In 1900 Egerton had driven a Locomobile steam car from John O'Groats to Land's End. Unlike a car, however, a motorcycle has little space aboard for the necessary spares and although it is not recorded that Egerton had a tender vehicle, it is likely that he received at least some outside help on his journey. One stop at Bristol for mechanical trouble is known to have cost him ten hours. The belt-driven front wheel of the Werner can clearly be seen in both photographs, at Land's End and John O'Groats.

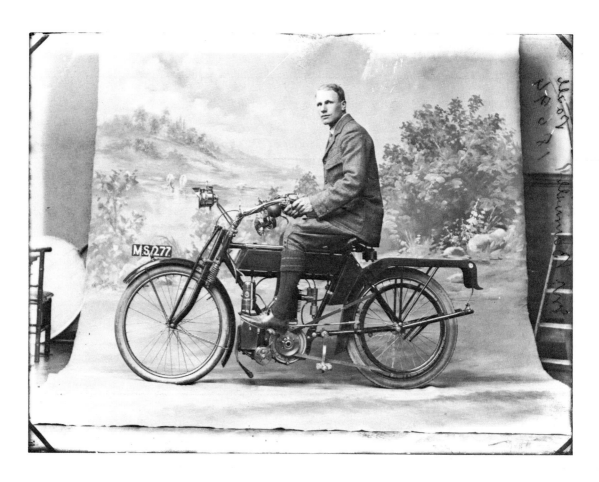

67 It was possible to get the motorcycle into a photographer's studio to make use of the highly ornate, painted scenic background against which family groups were posed. Painting these backgrounds was itself an art and in this case the artist has signed his work and dated it 1896, although the photograph was probably taken around 1909. A Mr Barnwell, on his brand-new Triumph, somehow contrived to stay upright whilst the exposure was made, although both his feet were on his machine.

68 Ladies were attracted to motorcycling as early as 1906. This special ladies' model of the Rex with a dropped frame and very elaborate belt guard had side strings to save the long coats from being caught up in the driving belt. A spare driving belt was attached to the front sprung forks, whilst a small tool bag proved that lady motor-cyclists had to know a little about the beast they were controlling. Our lady motor-cyclist, Miss Muriel Hind, wore a long, light, partially fashioned coat with masculine hat held on by a scarf. No doubt she would have been thought a little risqué for her time.

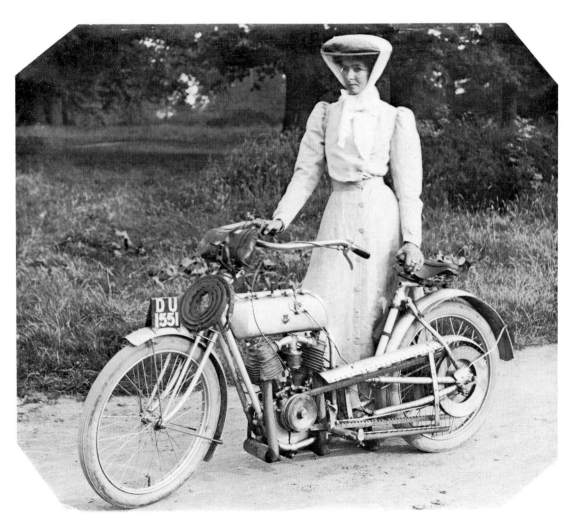

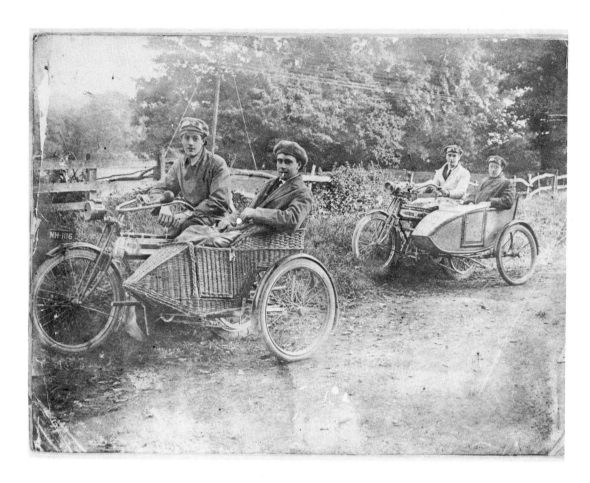

69 The motorcycle has always been a slightly antisocial device with no real place for a passenger. After early experiments with towed trailers came the sidecar. The first sidecar appeared in 1903 and was marketed under the name of the Liberty Social Attachment. Early examples were usually made of wickerwork and took the form of an open chair: racing sidecars are still affectionately referred to as chairs. Later types gave a little more privacy and had a small door. The all-metal, or wood, enclosed sidecar gave almost complete protection from the waist downwards; the device was popularised in 1914 by F. W. Mead, who was later to make Rhode light cars in Birmingham.

70 Motorcycle combinations were adapted for many purposes, this Rex outfit being fitted as a first-aid fire appliance. Such conversions were made by firms like Merryweather who were long famous as fire-engine designers. It carried a hand extinguisher, hoses, connections, and the like, and in some cases the motorcycle engine supplied power for a small pump. These smaller appliances usually reached the fire more quickly than the large fire engines, and their crew could prepare for the arrival of the pumper. Immediately before World War I steam fire pumps were still in common use, although the internal combustion engine had overtaken the horse as the prime mover.

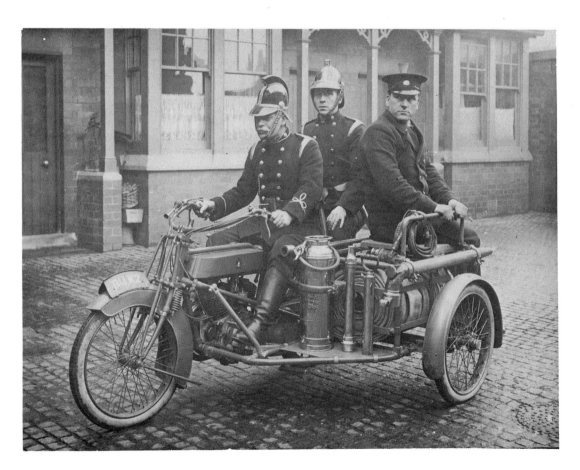

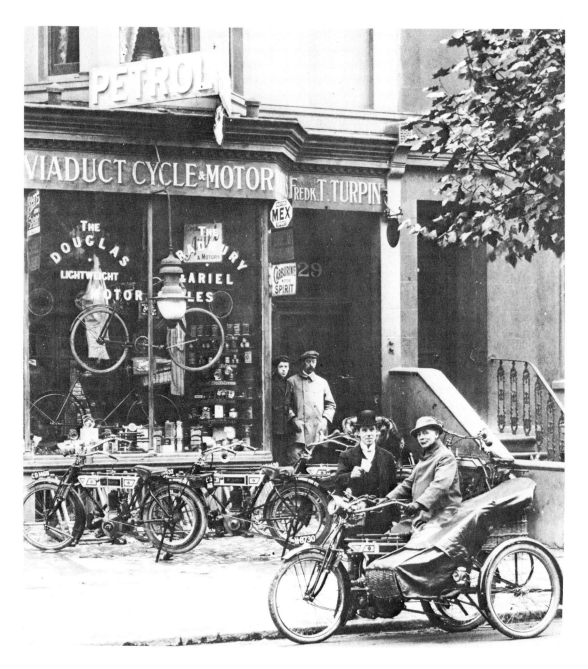

71 It was an obvious step for the cycle dealer to take on the sale and servicing of motorcycles. Frederick Turpin of Hove did just that. Besides the second-hand machines for sale on the forecourt of his shop in 1913, the window is full of accessories under the delightful collective name of cyclealities. As well as the inevitable tins of oil were tins of carbide for the lights, and numerous other spare parts. The basket sidecar had gained an apron to keep the upholstery dry.

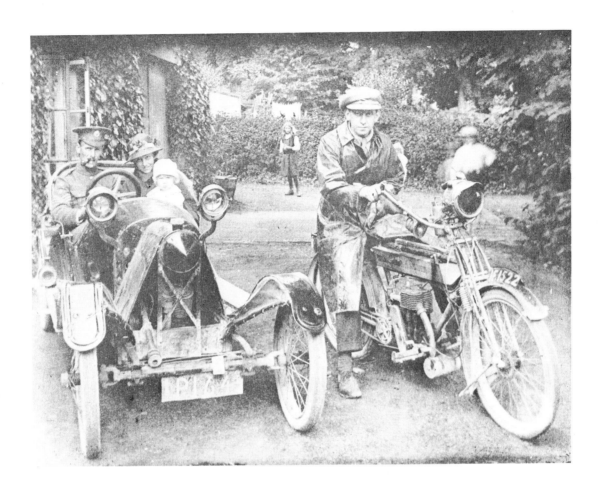

72 Before and after World War I a large number of small motor manufacturers sprang up, making light vehicles called cyclecars. One of the few to stay in business was the GN Company of Hendon, Middlesex, producing approximately two cars a week. This family snapshot shows a 1913 model and a Triumph motorcycle. The cyclecar was an attempt to woo the motorcyclist in the direction of four wheels but the cyclecar was little more than a four-wheel motorcycle without any of the advantages of car comfort. It was not until the coming of the Austin 7 in 1923 that the motorcycle had to give way to the car as a cheap means of transport. Most cyclecars had ash frames, motorcycle-type engines and, as on this GN, wire and bobbin steering. The drive was either by belt or chain to the rear axle. Cyclecars were notoriously unreliable and most owners soon reverted to the solo motorcycle or, if they had a family, to the motorcycle and sidecar.

SOCIAL MOTORING

73 In July 1897 Malvern Beacon was climbed by a motor vehicle for the first time. The car was specially geared down for the climb but a distinctive feature was the tiller steering, found on most early cars, as the steering-wheel did not come into general use until 1898–9. The horn at this time was not the decorative feature it became in later years but just a small ineffectual bulb with a twist mounted on the tiller.

In the front seat was the owner, the Hon Evelyn Ellis, with his daughter, and standing beside the bonnet, A. J. Drake, assistant works manager of the Daimler Company. Wearing the bowler, J. S. Critchley, the first works manager of Daimler's, was in the back, and next to him, Otto Mayer who worked with Gottlieb Daimler in 1889.

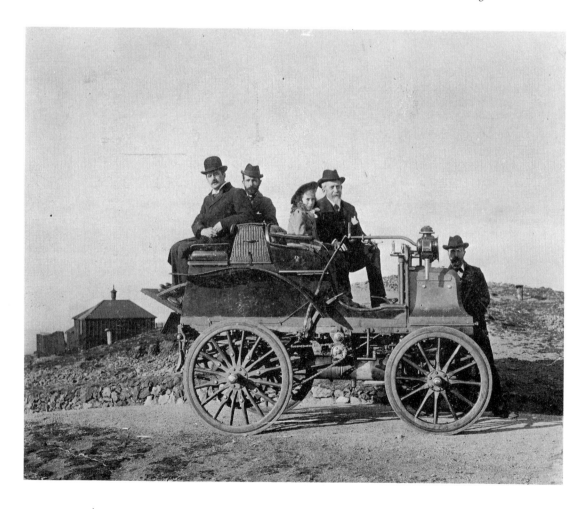

74 This photograph was found mounted on a piece of writing paper headed Trevin Towers, Eastbourne, and dated 'on 11th inst', probably 1898. The wording beneath the picture reads: 'An October expedition in the un-motored South Downs. Our arrival at a remote country hostelry—note flowers hanging from the beamed upper story. Mrs. Hissey on the car, Mr. Hissey not in the picture as he took it.' The car, a Cannstatt-built Daimler, clearly pioneered motoring in those districts hitherto unvisited by the horseless carriage.

75 (right) The complete motorist's picnic
outfit. The 1899 Panhard, fitted with a rear-
entrance tonneau-style of coachwork, readily
adapted itself to the picnicker's requirements.
The utensils were carried in a specially made
basket and the tea left to boil on a paraffin
stove on the rear steps over the very large
transverse silencer. An unusual feature of this
car, which was fitted with no weather
protection whatsoever, is the glass-enclosed
speedometer mounted in front of the steering-
wheel. With the police very active in trapping
motorists exceeding the 12mph speed limit,
this owner made sure that he would not be
caught.

76 (below) It was not necessary in 1905 to
pull off the road to find a quiet spot to eat:
the running-board doubled as a bar. Coats
had been discarded but the driver retained
his hat and goggles. Whilst brass car lamps
are collectors' items these days, this family
took the precaution of protecting theirs with
a tailor-made hood—very different from the
polythene bag seen at modern veteran car
events.

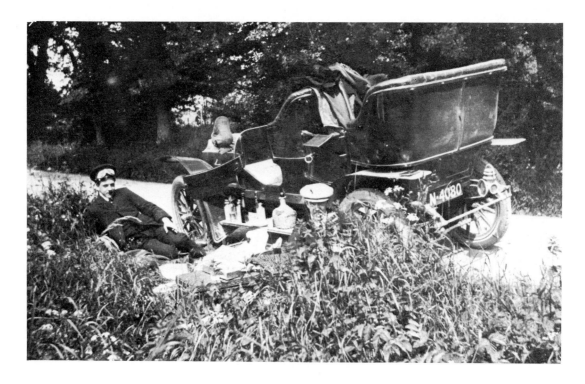

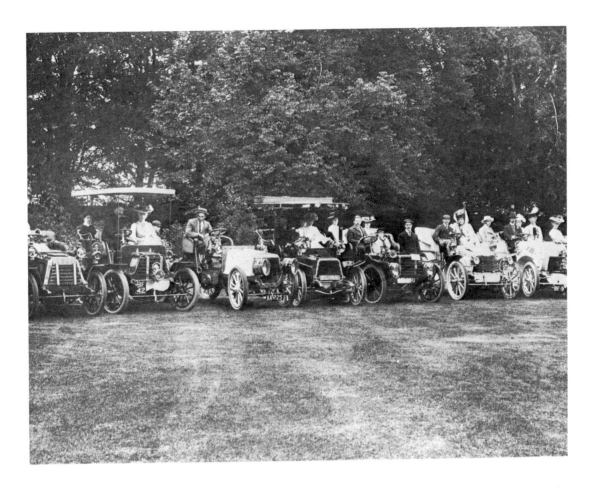

77 The coming of the motor car gave the gentry extra mobility and a new look to the garden party.

A garden-party motor meet at Wimborne in Dorset in the summer of 1904 was apparently an event of some importance. Participants included one or two with the unusual prefix BF in their registration numbers. Under the Motor Car Act of 1903, which came into force on 1 January 1904, all cars had to be issued with registration numbers. London had A, for example, A 1 went to Earl Russell for his Napier—the number-plate is extant and is owned by Dunlop. The letter B was allotted to Lancashire but no one in official circles had thought about the connotations of BF, which was given to Dorset. Some eighty-nine numbers were issued before it was stopped but insult had already been added to injury as a 'property' car, featured in the Royal Command Performance at the Garrick Theatre, appeared with the registration number BF 1.

78 One publicity stunt which escaped much notice by the Press in 1900 was an extremely difficult run undertaken by H. W. Egerton. From 11 to 22 December he drove a Loco-mobile steam car from John O'Groats to Land's End, encountering very bad weather on the way. The gale-force winds would have tended to blow out the burners but the advertisements afterwards claimed: 'No repairs to boiler nor any adjustment to any part of the engine were made during the entire length of the run.' The water consumption must, however, have been daunting.

The send-off from John O'Groats looks bleak, with not even the hotel staff there to wave, but on Egerton's arrival at Land's End, there were at least three people apart from a chambermaid to greet him. The extra lamp facing backwards by the driver's seat was

presumably used to throw some light on the boiler water-level gauge during night runs.

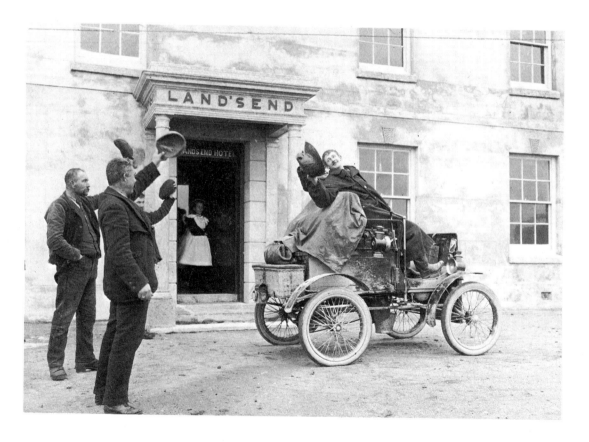

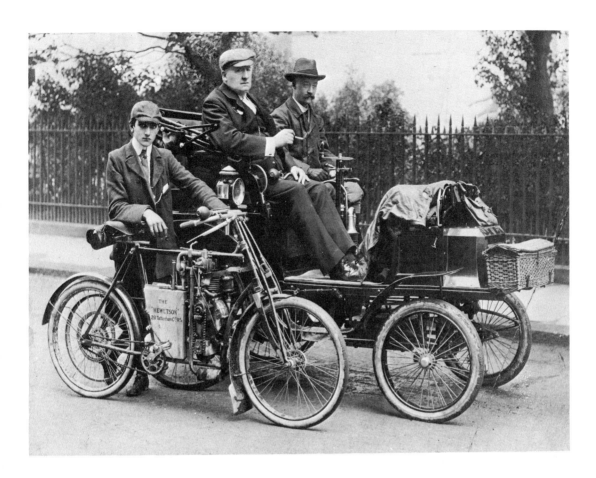

79　Henry Hewetson undertook to drive his 5hp belt-driven Benz for a hundred miles a day for three months of 1902. When asked why he took on the task, he replied: 'Well, you see, a large percentage of the outside public are still imbued with the opinion that motor cars break down, and I thought if I could drive a hundred miles a day for fifty days, taking just such gentlemen as would offer themselves, and a fresh one every day, the effect of such a drive, if accomplished without any breakdown which deserved the name of a breakdown, might help in removing an impression which you know is today an absurd one.'

The car completed the run with virtually no stoppages. The motorcyclist was St John Nixon, later an eminent motoring historian, who accompanied the Benz on some of its runs in case of punctures. It appears that Mr Nixon had little work to do, as the car only suffered three punctures in the 5,000 miles it covered. Pneumatic tyres were fitted to the front only, the rear wheels being shod with solids. Mr Hewetson was asked if there was any trouble with horses on the trip: 'Only once, and that at Camberley, where a horse, driven by a Captain Le Brett, twisted clean out of its harness and cut its back on the lamp.' The car was later auctioned and the proceeds given to charity.

80 One from the family album, 'Our visit to see the Wilmington Giant', taken about 1902. The family had motored into Sussex in an MMC, which stood for Motor Manufacturing Company of Coventry, a firm formed from the remains of H. J. Lawson's Great Horseless Carriage Company (1896). This concern's main *raison d'être* was the cornering of other people's patents, not to mention paper transactions involving large sums of money.

It was not unusual for family cars to be given nicknames, particularly before registration numbers became law in 1904. This car was the 'Seagull' with its name signwritten on the front of the scuttle; even the daughter of the family had 'Seagull' on her naval-style hat. The car may have been treated as an extension of the owner's yachting interests and used as a shore-based tender.

The Long Man of Wilmington is carved on the chalk on Windover Hill, Sussex, and may date from the mid-Saxon period.

81 A country shooting party? Who knows? This very new-looking vehicle was photographed off the road in winter. It is a four-cylinder Panhard of about 1902. The party had come prepared for muddy motoring, the rear pneumatic tyres having been laced around with chains to give more grip; the men, however, were not dressed for pushing should the car get stuck, as none are wearing long boots. This car had the most magnificent illuminations—acetylene headlamps, oil side-lamps and a movable acetylene spotlamp on the nearside. The sprag behind the driving chain was a rearward-pointing device to be let down by the driver should the car run out of control backwards or fail on a steep gradient.

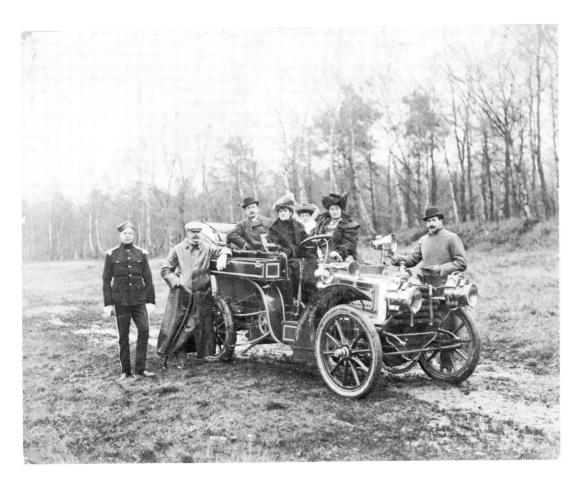

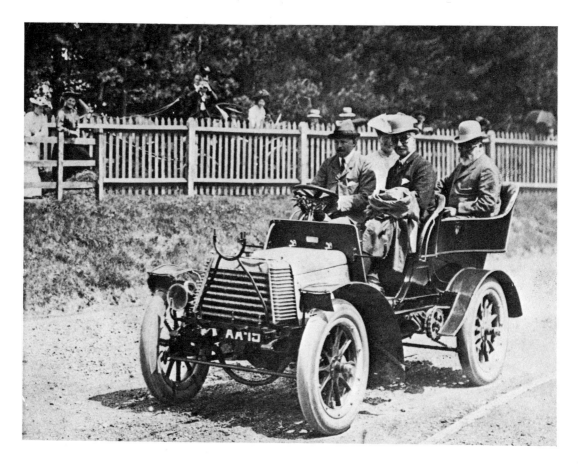

82 Queen Victoria spurned the motor car, although her son, King Edward VII, was the first royal motorist. Whilst Prince of Wales he had several motor rides, one of the first being on 14 February 1896, with the Hon Evelyn Ellis at the Imperial Institute in South Kensington. The car was a Cannstatt-Daimler and started an association between the Daimler Company and the Royal Family which continued until recent times. The prince purchased his first Daimler in 1900.

This photograph, taken on 19 July 1904, shows the king, with Lady Saville on his right, leaving Hinton Station near Christchurch, Hampshire, in the tonneau of a 22hp Daimler. The driver and owner of the car is the Hon John Scott-Montagu; seated beside him is the Hon H. Legge, equerry to the king. Daimlers were the house cars for the Montagu family at Beaulieu until 1908 and the registration number AA 19 is still to be seen on a Montagu car.

83 The ferry was often the shortest way to cross a river or estuary and saved a long detour to the first available bridge. Grove Ferry crossed the River Stour about six miles north-east of Canterbury and was being used by a 1904/5 Panhard. The ferry was not replaced by a bridge until 1962. Vehicles were charged by the number of their wheels.

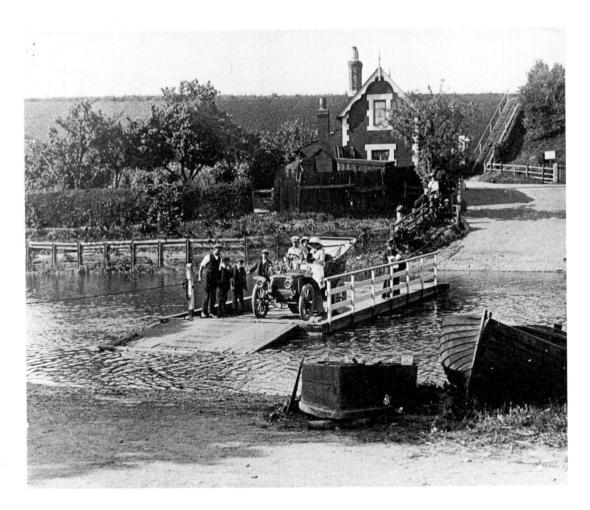

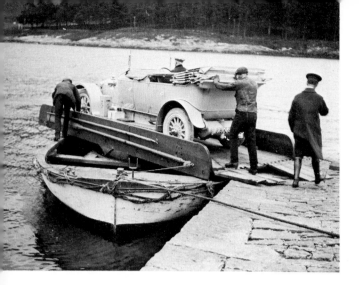

84 (left) To avoid the twenty-mile jour-
ney around Loch Leven, the ferry at
Ballachulish was a popular alternative. The
fare in 1909 was ten shillings for cars up to
12cwt, twelve shillings up to 15cwt, fifteen
shillings up to 1 ton, and one pound over 1
ton. With the introduction of larger ferries,
the charges these days are well below those
of 1909. It is apparent that the owner of this
Rolls-Royce Silver Ghost did not trust his
chauffeur to drive the car onto the ferry
platform; he did it himself.

85 (below) In the General Election of
1906, while many still felt that the car was a
toy of the rich, both parties used cars exten-
sively to take voters to the poll. It was thought
that the very high poll recorded at this time,
in some cases over 90 per cent, was due to the
distant voter, hitherto ignored by both
sides, being transported by car to the polling

booth. Some voters were carried over a hundred miles by party volunteers and one motorist in Kent was asked to go to Dartmoor to fetch two warders from the prison who were registered to vote in Chatham; unfortunately it is not recorded whether he actually went.

There was still much anti-motoring feeling in 1906 and *The Car* magazine in particular went to great lengths to list, both before and after the election, the candidates who were known to be 'favourable to automobilism'.

86 A car was a valuable commodity in Canterbury on polling day for the General Election of January 1910. Canterbury featured in the route of one elector who, being entitled to vote in six constituencies, on this occasion was determined to do his duty and vote at Norwood, Ashford in Middlesex, Alton, Newhaven, Herne Bay and Leigh in Essex. Such a journey would have taken two days by train but with the help of racing driver Charles Jarrott and the loan of a 45hp Napier from S. F. Edge, he managed to cover the total distance of 276 miles in just under twelve hours, with eight minutes to spare as he clocked in at Leigh. The longest and most devious part of the journey was from Newhaven to Herne Bay via Canterbury.

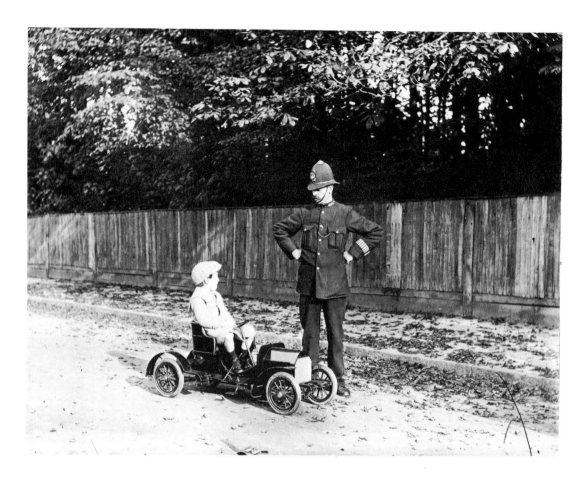

87 No number-plates, no insurance, no driving licence, and possibly even exceeding the speed limit, but there is no record of the outcome of this confrontation. During the Edwardian period a number of firms produced miniature motor cars for the children of the wealthy motorist; most of them were pedal-powered and beautifully made. This example was specially made by F. W. Hudlass, an RAC engineer, for his son in 1907. It is an exact one-third-size replica of a 28/32hp Mercédès. Everything about the car is as near to scale as could be made, and it even has special $1\frac{3}{8}$in × 12in tyres produced by Dunlop. It weighed 180lb. At one stage the car was taken to Brooklands and another photograph shows it posed with the car from which it was modelled on the banking of that famous racecourse. It is not known how the model was powered, but it was probably electric.

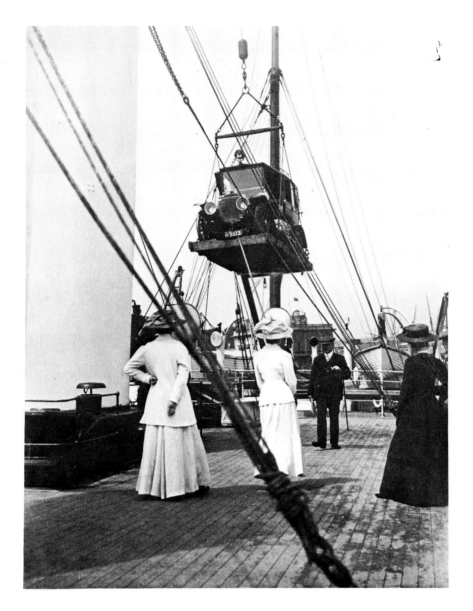

88 Once the motor car had achieved some reliability, the more affluent embarked on extended motor tours abroad. A 1908 Mercedes had to be lifted onto the deck of the SS *Queen* in July 1909 to reach Boulogne. Drive-on, drive-off ferries did not exist and figures published in 1907 by the South-Eastern and Chatham Railway show that it cost £4 single, at the owner's risk, or 5 guineas, at company risk, to ship a car from Folkestone to Boulogne. Damage was commonplace and cars had to be on the dockside at least two hours before the boat sailed.

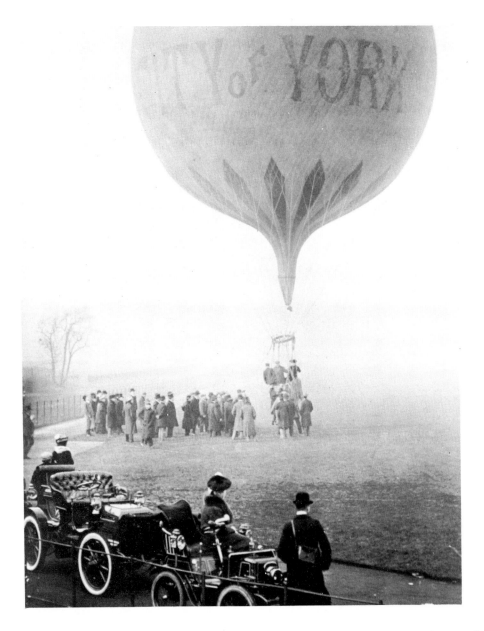

89 The first meeting of the Aero Club was held on 15 November 1901 and it got away to a good start by organising its first official balloon ascent. From these small beginnings grew the Royal Aero Club, the governing body for aerial sport in Britain. At that first-ever meeting Percival Spencer made an ascent with his balloon *City of York*. The larger of the two gentlemen in the basket may have been Frank Hedges Butler, the pioneer automobilist, the lady being his daughter Vera. The Hon Charles Rolls had made an ascent with Vera Butler in this balloon the previous September and whilst flying over London conceived the idea of forming the Aero Club.

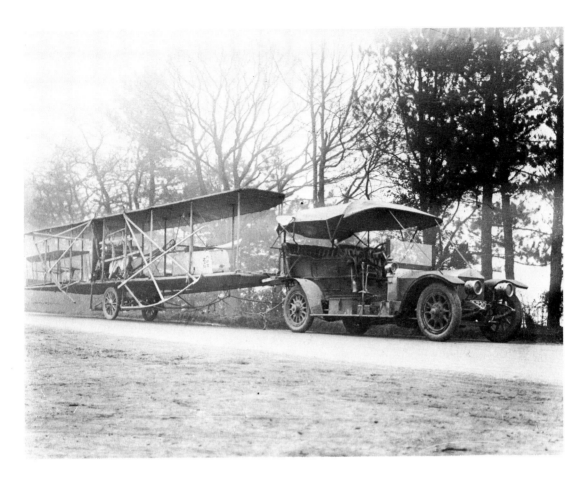

90 Many aeronauts turned to powered flight and one such was the Hon Charles Rolls, so tragically killed in a flying accident at Bournemouth in 1910. In the pioneering days of flying, aeroplane meets were held at many different places throughout Britain but it was more normal to transport your plane from venue to venue than to fly it. Some aviators such as J. T. C. Moore-Brabazon were able to dismantle a plane in such a way that it would fit on the back of an extended car chassis, in his case that of a Renault. C. S. Rolls used a Rolls-Royce Silver Ghost to tow his aeroplane but not his famous balloon tender. One motoring wag once remarked that this was the forerunner of the *Queen Mary* aeroplane transporter.

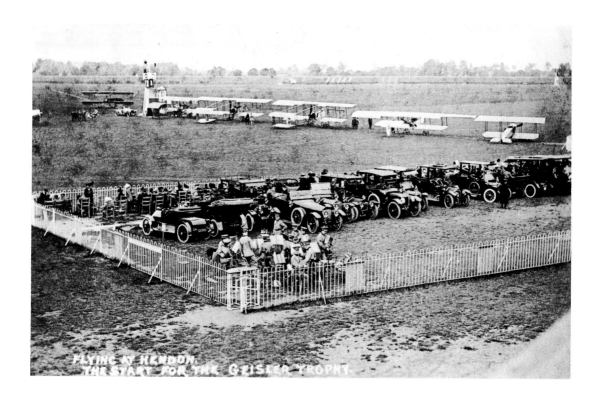

FLYING AT HENDON.
THE START FOR THE GEISLER TROPHY.

91 Attending aeroplane meets was a popular pastime for the public. At first these events took place on any suitable piece of ground, but slowly permanent flying-fields came into use. The field at Hendon was probably the best known and sported a special spectators' enclosure for a Geisler Trophy race meeting. Conveniently parked close to the start and finish line of the races, these guests had chairs provided but some still preferred to use their cars as grandstands. Presumably the band only played when the engines were switched off.

92 Two local motorists lent their cars to help with the Queen Alexandra Rose Day Appeal on Charity Day at Epsom, Surrey, in June 1911. They were photographed before setting off on their money-raising campaign, an Armstrong-Whitworth on the left and a Delaunay-Belleville on the right. The near-side front tyre of each car had a studded tread, whilst that on the offside was virtually plain. This was supposed to help counteract skidding on wood block or stone-sett surfaces.

93 July 1913 saw a large society wedding in the Essex village of Wickham Bishops, when Mr G. Duncan Rowe married Miss Frances Mary Allen. After the service the bride, groom and guests were conveyed to the reception in no less than seventy decorated cars—surely one of the largest wedding motor processions of the period. The line-up outside Glovers Garage at Witham included a Rolls-Royce Silver Ghost, probably the bridal car, and a Renault limousine. The *Essex Weekly News* commented that the bride and bridegroom 'left later in the day for their honeymoon which is being spent on a motoring tour'.

94 By 1910 camping with the motor car was becoming popular, although the caravan as we know it today did not appear until the Navarac Caravan Company's first production in 1919. A few large-car or commercial-vehicle chassis, however, were fitted with 'one-off' living van bodies around 1908; so the motor caravan preceded the trailer. This photograph was taken as a publicity shot in 1913 to show what the well-equipped camper ought to have for his comfort. How all the paraphernalia was to be carried in a single car was not explained. Sporting the flag of the Automobile Camping Club, the car, for all its elegant Métallurgique-like Vee radiator, was probably an American Oakland Six with British bodywork.

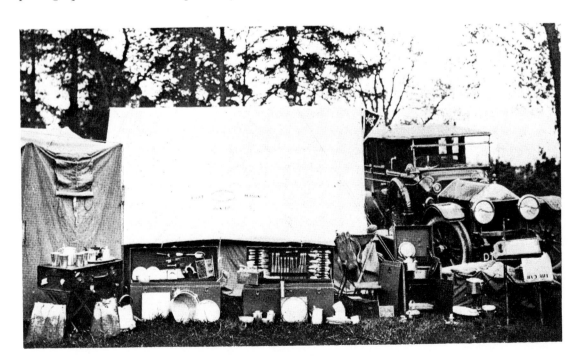

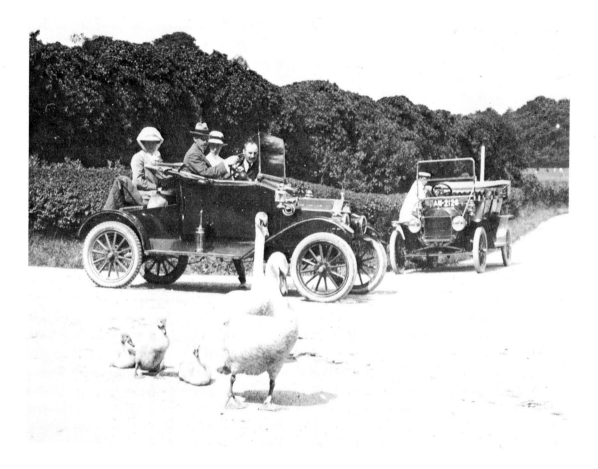

95 Touring Tin Lizzies. Model T Fords, meet at Beaulieu in 1913, one a four-seater touring version, the other a simpler and cheaper runabout with dickey seat behind. The Model T Ford was developed as a relatively cheap motor car for the un-mechanical. In 1919, 41 per cent of the motor vehicles registered in Britain were Fords. The Model T was made from October 1908 through to May 1927, and over fifteen million were produced, but from 1914 to 1925 the only colour offered was black. So common was the Ford T that a large accessory industry grew up around it, the main aim being to sell the owners items which would make the cars look less like Fords.

SPORTING MOTORING

96 The sporting automobilist wanted more than ordinary touring; he wanted to race. The very first successful sprint meeting held in Britain formed part of the 1,000 Mile Trial of 1900 and was held at Welbeck Park on the estate of the Duke of Portland. This photograph shows some of the cars preparing to come to the start line with the Hon John Scott-Montagu's 12hp Daimler about to leave and, in the foreground, Mr Exe's Parisian Daimler and the Wolseley later made famous by St John Cousins Nixon who used it for three re-enactments of the 1,000 Mile Trial in later years. The Welbeck speed trials were unusual inasmuch as the cars were timed from a flying start and made a run in each direction of the course. As the return run was downhill, the difference in their times was considerable, a factor which ruled out Welbeck as a venue for early attacks on what later became the world's land-speed record.

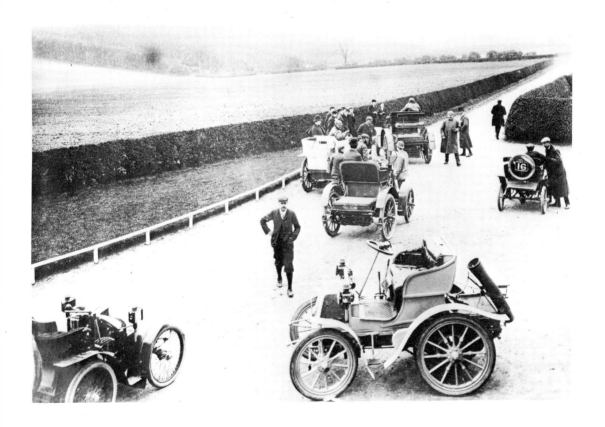

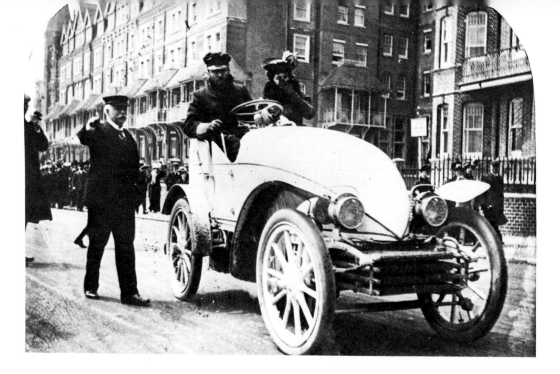

97 (above) The first seaside speed trials to be held in England took place on 19 May 1902 on the promenade at Bexhill. Seaside speed trials are still held regularly at Brighton and Weston-super-Mare, although the last meeting at Bexhill was in 1924. The course for the 1902 meeting started with a 155yd dash downhill and so the cars were timed from a flying start. The meeting attracted a large entry and huge crowds. The fastest time of the day was made by Léon Serpollet driving his very potent steam sprint car which had the delightful nickname of the 'Easter Egg'.

98 (below) The Automobile Club held a large-scale event in the South of England in September 1903 called The Thousand Mile Trials, not to be confused with the 1,000 Mile Trial of 1900. The 1903 event was basically a series of observed and controlled tests for braking, hill starting, noise, dust and vibration as well as speed on a number of hill climbs, and the results could be used by manufacturers to advertise their vehicles. J. W. Dew with his Gardner-Serpollet steam car took Westerham Hill in Kent at speed, passing judges and observers, but as the roads were not specially closed for the occasion he had to negotiate a horse and cart halfway up the slope.

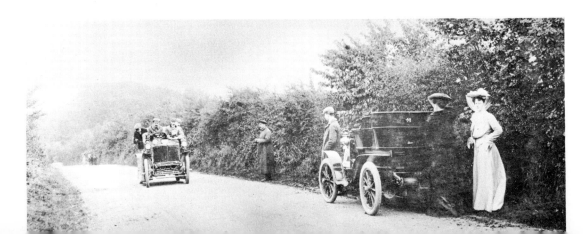

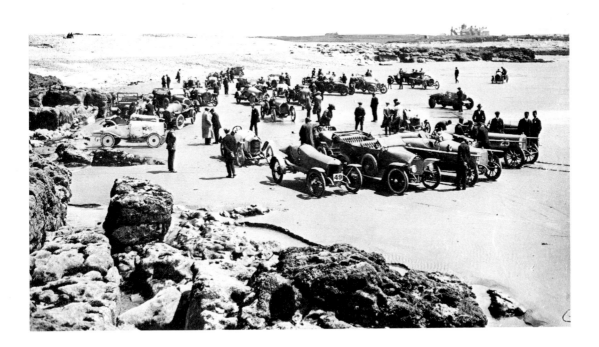

99 From 1909 onwards speed trials and racing on sand became popular. Pendine Sands in South Wales was probably the most popular venue, but by 1920 Southport had become the most famous resort to host this type of racing. Included in most sand race meetings would be classes for ordinary touring cars such as the Humbers here. There would also be classes for the more sporty cars such as Talbot, Hispano-Suiza, Sunbeam and DFP, as well as for racing cars and specials. Sand race meetings did more damage to the car than any other motor sport, with sand and salt penetrating even the most inaccessible parts of the mechanism.

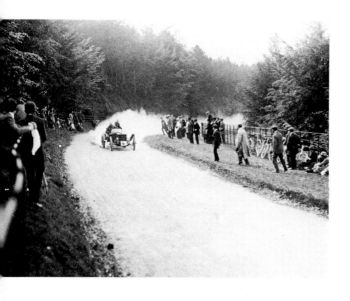

100 (left) One of the most popular forms of motor sport during this period was speed hill climbing. These events usually took place on roads on private estates. A famous venue was Aston Clinton and cornering his *Coupé de L'Auto* Vauxhall with great verve in 1913 is Vauxhall works driver A. J. Hancock. It was fitted with an experimental engine which subsequently powered the very successful and now much sought after 30/98 Vauxhall which first appeared in any quantity in 1919. The first one was built for sprint enthusiast Joseph Higginson in 1913. It is surprising that there were not more accidents at these events, caused by cars running out of control into the spectators. Crowd control was negligible and the disaster at Kop in 1924 still lay far in the future.

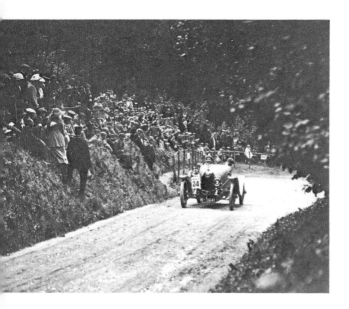

101 (left) Shelsley Walsh hill climb in Worcestershire was pioneered by the Midland Automobile Club in 1905 and meetings have been held there ever since. One of the most popular and difficult courses in the country, it has always attracted top-line drivers and first-class cars. For many years the 'specials', which were specifically developed for speed hill climbing at this and other venues, were collectively known as Shelsley Specials. At the last pre-war meeting of 1914, Cecil Bianchi is here shown driving a 15.9 Crossley, a model known in sporting circles as the 'Shelsley'. As at all hill climbs of this period, if your car was a two-seater, you had to carry a passenger, and of course crash helmets were unheard of.

COMMERCIAL VEHICLES

102 Steam was used on the farm for years before the arrival of motor transport on the roads. One of the heaviest types of traction engine was the massive ploughing engine which usually operated by contract on farms where a deeper furrow was required than could be produced by a horse plough. An engine would stand on either side of the field and the plough would be pulled across on a hawser attached to the winching drum under the boiler of each engine. When moving between jobs, these engines would often take up the full width of the country road and their weight was a problem on bridges. Here, two sets of ploughing tackle leave Leeds, the home of Fowlers their manufacturers. The front pair with canopies were most probably for export.

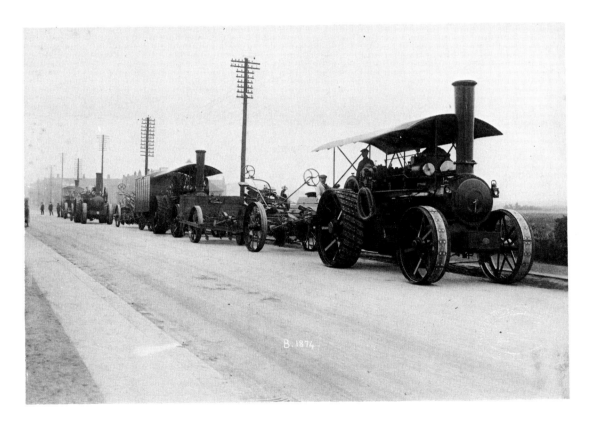

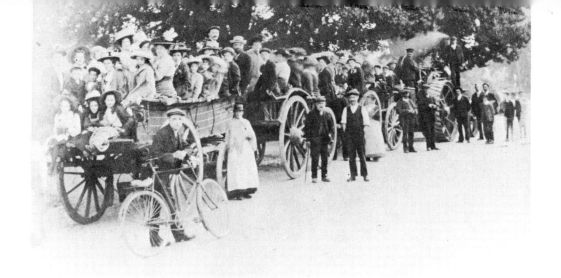

103 (above) The Marshall traction engine belonging to Bakers of Compton in Berkshire takes time off from its normal agricultural duties. It had been drafted in to take the annual chapel outing from the village of East Ilsley to Reading in the summer of 1911. The charabanc gradually took over but prior to World War I the annual treat, or wayzgoose as it was known in some parts of the country, assumed many forms. On occasion even the narrow boats on the canals substituted seats for cargo.

104 (below) Heavy haulage was the preserve of the traction engine until the late 1920s and some were still being used for this purpose as late as 1950. In 1903 two road-haulage engines had been commandeered to take a 40 ton block of Cornish granite from the quarries at Penrhyn to Winchester, where the stone was to form the base of the King Alfred statue. The engine at the rear was used for braking and was coupled to the front engine for hill climbing. No doubt such a load would have been followed by another engine towing a living van for the crews, together with water and coal carts.

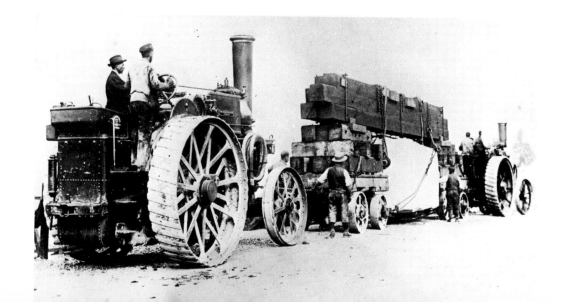

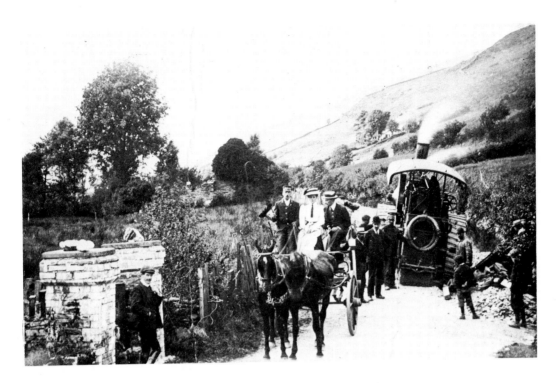

105 Country roads were the undoing of the heavy traction engine; the worst hazard being collapsing metal at the verges. Here, a Fowler had fallen through the surface on a narrow road between Towyn and Talyllyn in Merionethshire. The engine crew were faced with the task of lifting the engine back on to firm ground, achieved by jacking and packing. The party of horsedrawn sightseers, appearing to take no notice, were doubtless on an afternoon's jaunt from the Victorian seaside resort of Towyn-on-Sea to the Talyllyn Lake. Presumably they scorned the Talyllyn Railway which would have taken them part of the way.

106 This Mann steam wagon was too heavy for the weighbridge. The accident happened in May 1907 in a London railway yard of the London and South Western Railway, probably Nine Elms. The lorry was fully loaded with hay—fodder for the large number of horses employed by the railway company for London deliveries. The Mann's Patent Steam Cart and Wagon Company of Leeds was one of the first firms to make a steam lorry for delivery work to replace the more common traction engine and its trailer. As with early petrol lorries, no protection was provided for the driver and because of the heavy loads; traction engine-type metal-tyred wheels were used rather than solid rubber tyres.

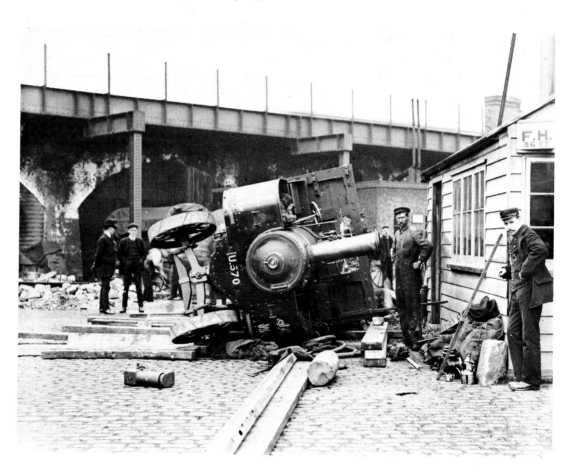

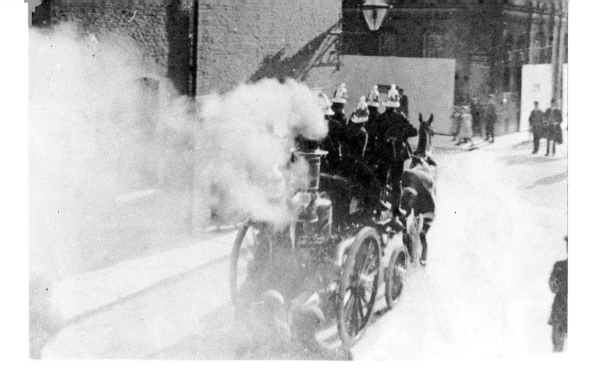

107 Firms such as Merryweather and Shand Mason made many varieties of steam-driven pumping engines for use by fire brigades. In the latter part of the nineteenth century these were horsedrawn. They continued to be used during the Edwardian period but were rapidly superseded by the motor fire pump, although some brigades kept the steam pump and mounted it on a lorry chassis. It was amazing how quickly steam could be raised and pumping started; the forced draught on the journey to the fire meant that the former process took only ten to fifteen minutes.

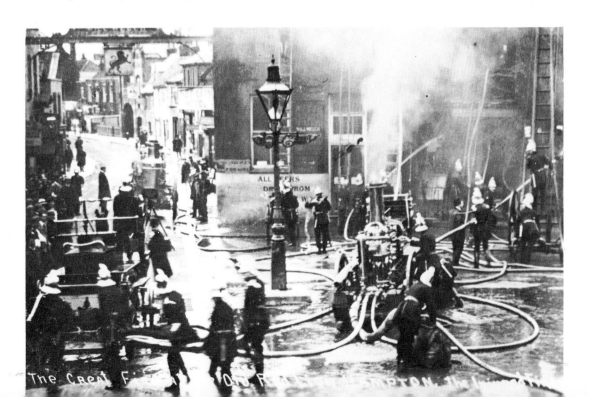

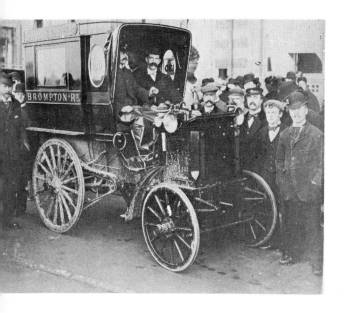

108 (left) Harrods of Knightsbridge was one of the first London stores to use the automobile for deliveries, their imported Panhard Levassor van-cum-bus dates from mid-1896 and was photographed at Brighton at the end of the Emancipation Run, which it completed satisfactorily. The vehicle was tiller-steered and with little caster angle in the system it is likely that the effect of every rut and pothole was transmitted straight to the driver. In later years Harrods were famous for their large fleet of electrically propelled delivery vans, some of which they made themselves, and it was only in the 1960s that these came off the road.

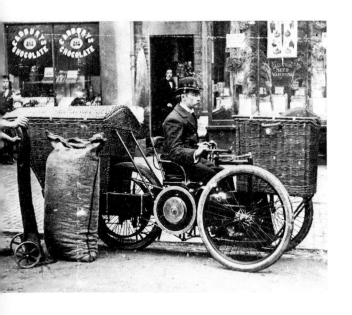

109 (left) Deliveries 1897 style, a Coventry Motette three-wheeler adapted to serve as a light parcel carrier. This must surely be a publicity picture because it seems most unlikely that the machine could have carried such a heavy sack. Certainly this was no vehicle for a driver of short stature as he would not have seen over the front basket. Right from the early days of the commercial vehicle, equipment was sparse.

110 (right) This 1900 Coventry-Daimler, fitted with a private bus body, was built to the order of Mr J. Laycock, most probably for the purpose of collecting guests from the local station. The passengers travelled in comfort whilst the driver was exposed to the elements. Side chains provided the drive to the rear wheels and the differential was mounted on the rear of the gear-box on the cross-shaft, immediately under the driver's seat. The position of the steering-wheel was curiously nautical and peculiar to the larger Daimler commercial vehicles. The smaller front wheels were a survival from the carriage where it was necessary to allow the front wheels to pass under the coachman's box when on a lock. It was not until after 1900 that equal-sized wheels became common practice.

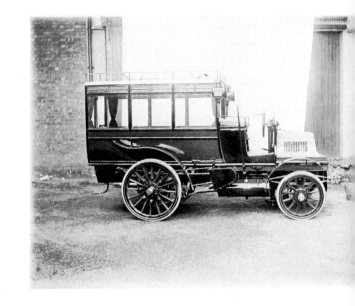

111 (right) H. Bugbird of Hamilton Road, West Norwood claimed to be the first rag and bone merchant to use an automobile for his rounds. He was at first worried that he could not afford to use a motor vehicle, but later recalled that it was as cheap to run as a horse and cart—he sold his horses as a result. His first vehicle was this Panhard-Levassor, about 1904, with a body to his own design. The load-carrying part of the body was removable and Mr Bugbird had made a beautiful four-seater touring body which could be fitted on to this chassis for weekend and holiday use, so giving no indication as to the owner's trade. The touring body is still in existence on a restored veteran car, although the Panhard chassis has long since been scrapped.

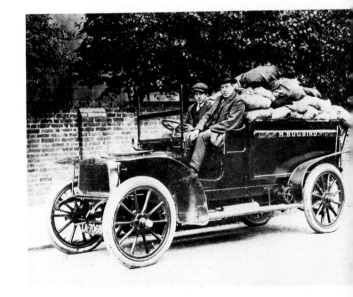

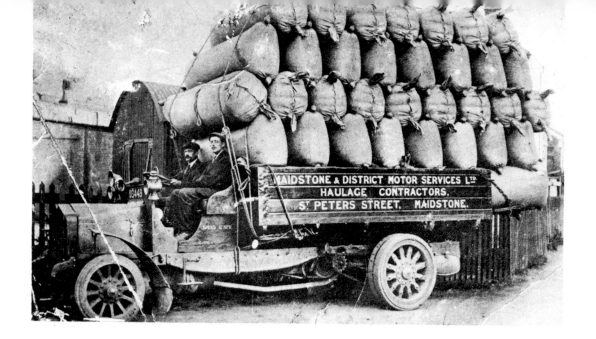

112 (above) The 1907 Hallford was one of the first buses to be used by Maidstone and District Motor Services, but they were fitted with removable bodies. At night-time, after the daily passenger services had been completed, the bus bodies were replaced by lorry bodies of differing types and the vehicles used to transport loads, in this case hops from Kent to London. The following morning they would be back in use as buses.

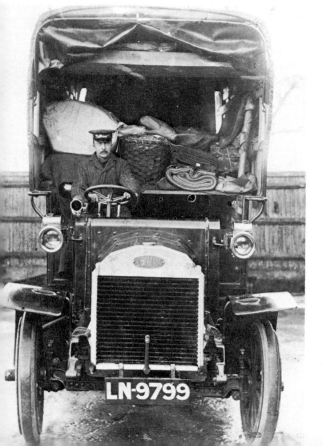

113 (left) Ready for the road . . . this driver of a 1911 Dennis lorry posed before taking out the first delivery of the day. Equipment on the lorry was sparse, there was neither weather protection nor headlamps, although no doubt the driver would be expected to travel long after dark should he be delayed on the journey. Commercial vehicles continued to use solid tyres for a couple of decades after cars had pneumatics, mainly because manufacturers and users doubted whether tyres with tubes would stand up to heavy commercial wear and tear.

114 (right) Delivery vans mounted on private car chassis, such as this 1912 16/20hp Vauxhall, were usually built to a higher standard of driver-protection than lorries of the same period. Even though the windscreen did not reach the cab roofline, the driver was not entirely unprotected from the elements. In later years many delivery vans and lorries took on the shape of the product they were carrying. Probably the most famous were the bottle-shaped Spyker and Daimler vans of Bass-Worthington, and Watney's barrel; one van even appeared in the form of a tube of toothpaste.

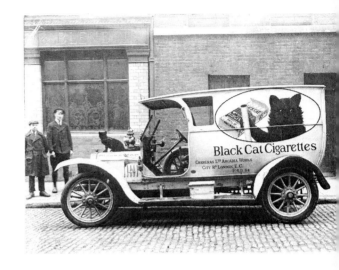

115 (below) In 1915 this Redhill, Surrey, bakery was employing several different types of delivery vehicle. Mr Barber had not discarded the baker's delivery handcart, roundsman's bicycle or tricycle with box despite his two motor vans. The one on the left is a Model T Ford while the other looks like a conversion of a 9.5hp Stellite light car. The coming of the motor van allowed the firm to employ ladies on the baker's rounds, a wartime emergency measure.

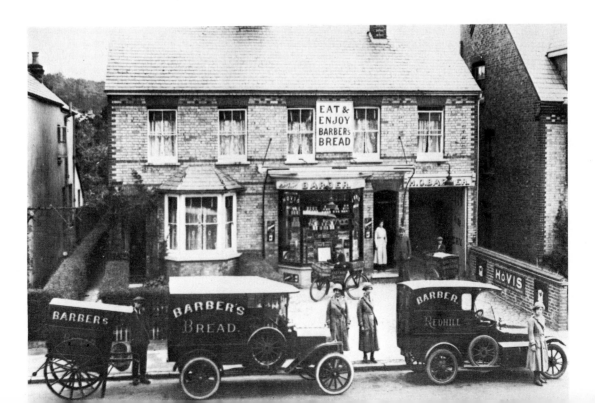

BUSES AND TAXIS

116 A feature of many late-Victorian and Edwardian towns and cities was the tramway system. In the early years they were often steam-powered like these in John William Street, Huddersfield, around 1896. The steam tram engines were the work of Thomas Green of Leeds and Kitson and Company. On the rear dash of the middle car is a postbox, a local feature of Huddersfield Transport vehicles from 1893 until the end of tramway working in 1940. In steam tram days a fee of one penny was payable if the tram had to be stopped specially for the posting of letters.

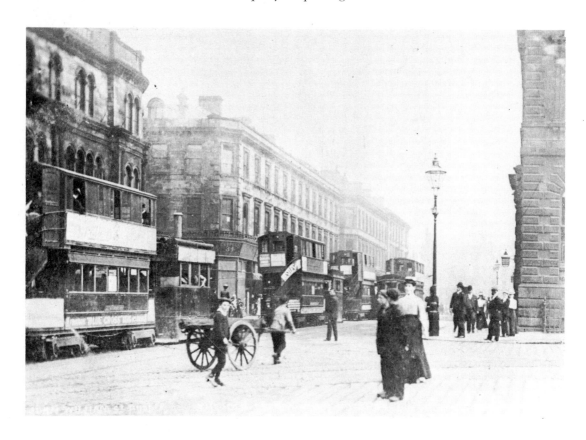

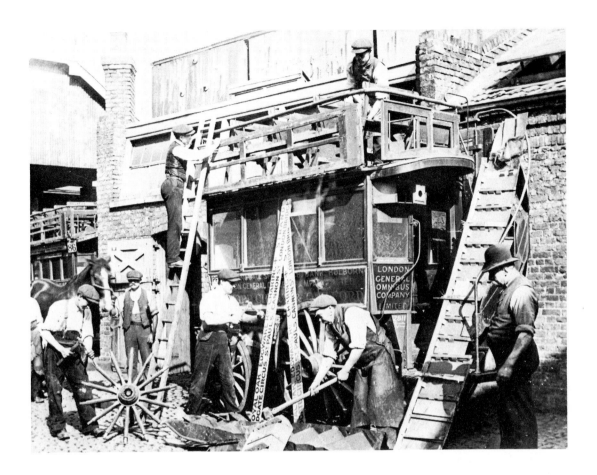

117 The horsedrawn bus, for long such a familiar sight in London, finally gave way to the motor bus in 1915. In preceding years many horsebus bodies were destroyed, as can be seen in this picture of May 1911. The very large stable of horses was also disposed of, many unhappily going to the knacker's yard. Most bus bodies were broken up, though a few were sold as sheds or summerhouses and two were even converted for use as workmen's carriages on a mineral railway.

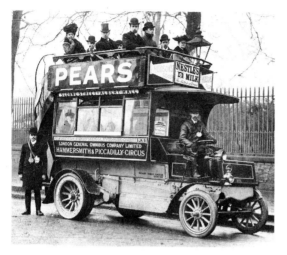

118 (left) It was quickly recognised that at least some of the horsebus bodies could be utilised for other purposes. In 1904 the LGOC experimented with a Swiss-made Orion chassis specially adapted to take such bodywork, operating it initially on their Hammersmith to Piccadilly service. This particular vehicle was withdrawn in 1906, possibly because it was underpowered. However, the Victoria Omnibus Company took many more Orions, but they were fitted with specially constructed bodies.

119 (below) The driver and conductor of an Arrow bus in London about 1906. In the earlier years of the London bus, each of the rival companies used a short catchy name instead of the full company title. For instance, the London and District was Arrow, London Motor Omnibus Co Ltd was Vanguard, and the Motor Bus Company was Pilot. Like other contemporary commercial vehicles the driver had no protection, although some heat and a lot of noise would reach him from the raised engine cover in front. The lamp and horn appear to be afterthoughts. A number of drivers were recruited from horsebus operations and retrained.

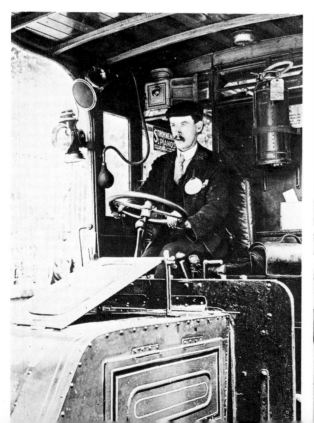

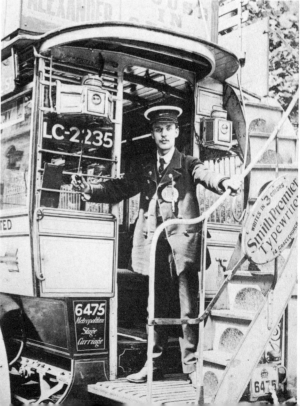

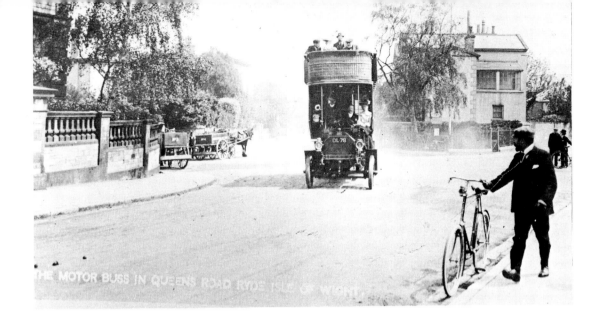

120 (above) The Isle of Wight Express Motor Syndicate bought seven Milnes-Daimler double-deckers in 1905 to provide one of the island's first motor bus services. The large wicker basket over the driver's compartment held up to 5cwt of parcels whilst a postbox was attached to the exterior on the nearside of each bus. In the same year five-shilling Rover tickets were issued for holiday-makers.

121 (below) One of the National fleet of Clarkson paraffin-fired steam buses being used for private hire in Chelmsford in 1909. Thomas Clarkson was interested in the Territorials and the Scout movement— hence the name National and the recruiting slogans on the bus. The Clarkson steam bus was a familiar sight in London until about 1919. It was the success of using buses on manoeuvres such as this which led to hundreds of LGOC B-types being used on the battlefields of Flanders for troop transport.

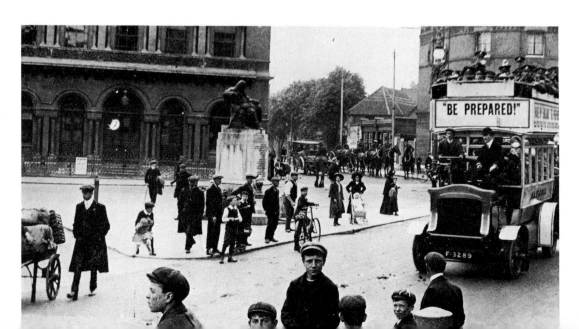

122 (above) As long ago as 1903, Bartons were taking trippers from Weston-super-Mare to Cheddar Gorge by 12hp Daimler Waggonette. This 1912 or 1913 party were about to leave for the Yorkshire beauty spot of Hayburn Wyke in a Hallford, probably dating from 1908. The long bench seats and gradually rising platform were typical and there was even room for a passenger on the driver's offside.

123 (below) If you did not own a horse-drawn vehicle or a car, the country bus service was for many years the only way in which people living in outlying farms and villages could reach the local town. This 32hp Albion was operated by the Kingswinford Motor Services and only just survived the war, being scrapped in 1919. The removable window-frames are unusual. The bus had solid rubber tyres and was therefore restricted by law to a maximum speed of 12mph.

124 Taxi or charabanc? The vehicle is a 1904 10hp two-cylinder MMC and it plied for hire between Folkestone and Hythe in Kent; the fare for this journey was one shilling single in 1904. The rear mudguards were more suited to a paddle steamer than to a car although they protected the driving chains as well as deflecting mud. Very thin-section solid tyres are fitted all round.

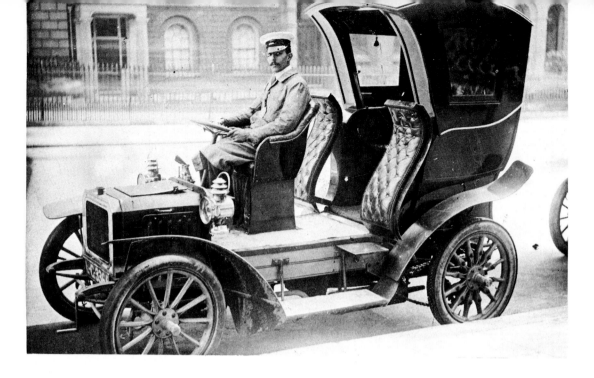

125 (above) The early London taxi cab took on a number of differing styles but with many horsedrawn hansom cabs still running, it was logical that cab design should follow these closely. The rear of this French-built Hérald taxi photographed in 1905 is an authentic hansom. The Vauxhall cabs of the period followed traditional lines even more closely, with the driver perched high up at the rear. The passenger was unnerved by this practice as he could not see anyone actually controlling the machine and so the Vauxhall fleet was withdrawn and replaced by Héralds.

126 (below) The chain drive can clearly be seen on a pair of Rational motor cabs photographed in the Strand in 1906. Unlike the Hérald taxi, the Rational had a full-height door and therefore fully protected its passengers from the elements. Though forms of taxi-meter had been tried on horsedrawn hansoms, it was not until March 1907 that the first appeared on a motor taxi. By July 1907 they had been made compulsory on motor cabs and the fare was fixed at eight pence a mile; a tip of two pence in the shilling was suggested.

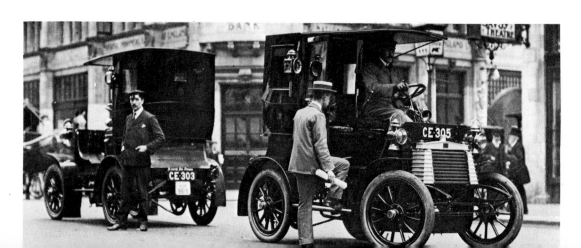

127 (right) Taxis in the foreground in a rank in Knightsbridge in 1907 are Renaults, with older models of unknown type behind. Most have some form of anti-skid attachment at the rear; the solid tyres being protected by chains whilst one of the pneumatic-tyred cars has a patent 'tie on' metal-studded tread. It was a ruling that London cabs should have a studded tyre on diagonally opposite wheels at least to lessen the skid risk on London's wood-block roads. Until the late 1930s most London taxis were of landaulette type, allowing the passenger to sample London air if he so wished.

128 (below) A day off for a London cabbie when he was hired by some enthusiastic race-goers to take them to the Derby at Epsom in 1910. The roof of the Renault made an ideal grandstand and the party obviously enjoyed the racing. The leather hood on the rear part of the bodywork supported the weight of a man.

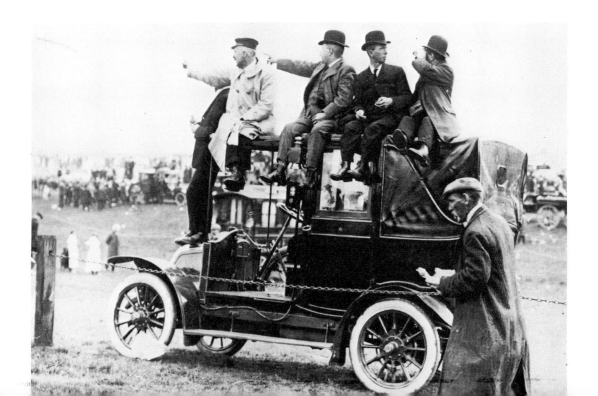

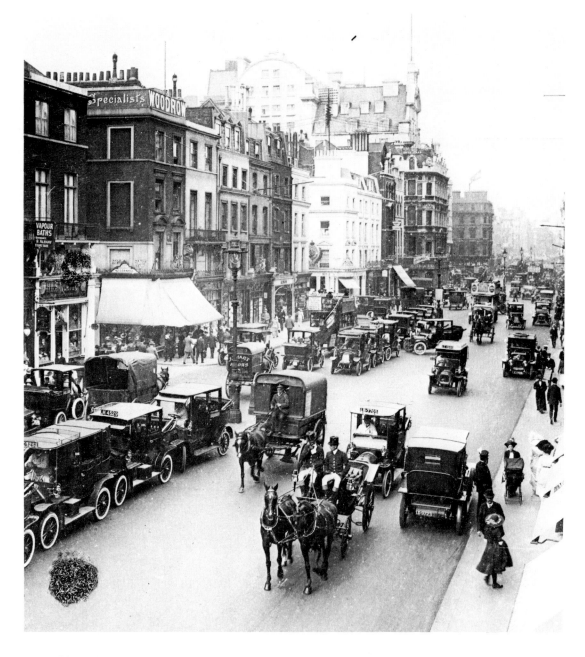

129 Piccadilly in 1914 saw all types of traffic, both private and commercial. Large numbers of taxis were in evidence—parked in cab ranks, picking up fares and one even doing a U turn. There were a number of buses as well as horsedrawn delivery vans and carts, at least one private horsedrawn phaeton with liveried coachman, and the inevitable private cars. Very little has changed in the scene of today as regards the types of traffic, but horsedrawn vehicles are limited to brewers' drays and the occasional publicity stunt.

INDEX

In general, car makes are sure to be found under the better-known name, e.g. Arnold-Benz will be under Benz and Coventry-Daimler under Daimler.

Lowestoft, Suffolk, 34
Lutzmann, 15
Lyon, John, 54

Mail on trams, 102
Malvern, Worcs., 68
Mann (steamer wagon), 96
Maple and Co., 34
Market Drayton, Salop, 51
Market Harborough, Leics., 48
Marshall (Traction vehicle), 93
Mascots, 44
Mass-production, 39
Mayer, Otto, 68
Mead, F. W., 64
Mercédès, 30, 50, 51, 80, 81
Merryweathers, 65, 97
MMC, 74, 107
Montagu, 2nd Lord, of Beaulieu, 44, 76
Moore-Brabazon, J. T. C., 83
Mors (car), 34, 45
Motor Car Act (1903), 40, 57, 71
Motor Car Club, 18
Motor cycling, 60-7
Motor Manufacturing Company (MMC), 74, 107
Motosacoche, 60

Napier, 54, 58, 71
National Motor Museum, 9
Newcastle-Upon-Tyne, 21
Nicholl, Vera, 42
Nixon, St John Cousins, 73, 89
Norton, Suffolk, 40

Oakland (car), 87
Oldsmobile, 39
Orion chassis, 104

Panhard, 19, 40, 70, 75, 77
Panhard-Levassor, 15, 33, 40, 98, 99
Paraffin firing, 105
Patrol Boxes, 57
Pendine Sands, Wales, 91
Penny-farthings, 13, 44
Penrhyn, Cornwall, 94
Peugot, 15, 40, 56
Phaetons, 11, 110
Ploughing, 93
Pneumatic Tyres, 14, 48, 73, 75, 100
Pramotors, 23
Prams, motorised, 23
Pratts' Spirit, 49
Preston, Lancs., 58

Pullman, 35
Punctures, 43, 48, 73

Q model, 26
Queen, S. S., 81

Racing, 89-92
Rag and bone cart, 99
Rational (taxi), 108
Reading, Berks., 20
"Red Flag Act" (1896), 11, 16, 57
Redhill, Surrey, 101
Registration numbers, 71
Reigate, Surrey, 18, 19
Reliability trials, 20, 21, 89
Renault, 42, 51, 56, 83, 86, 109
Rex, 63, 65
Rhode (car), 64
Rider, A. G., 27
Riley, 55
Robey engine, 13
Rolls, Hon. Charles, 40, 82, 83
Rolls-Royce, 51, 78, 83, 86
Rover (car), 64
Rover tickets, 105
Rowe, G. Duncan, 86
Royal Aero Club, 82
Royalty and cars, 76
Royce, Frederick Henry, 40
Russell, Earl, 71

Sadler, C., 39
Safety glass, 31
St Christopher, 44
Salomons, Sir David, 15
Saluting by AA patrols, 57
Saville, Lady, 76
Scott-Montagu, Hon. John, 21, 76, 89
"Seagull", 74
Self-starters, 29
Serpollet, Léon, 27, 90
Sewell, Edwin, 53
Shand Mason, 97
Sheffield, Yorks., 22
Shelsley Walsh hill climb, 37, 92
Siddeley, *see* Wolseley
Sidecars, 64, 67
Simms, Frederick R., 16, 19
Singer (car), 25, 46
Sizaire-Naudin, 58
Skidding, 58
Skyker, 101
Slough, Bucks., 17
Southport, Lancs., 91
Speaking tubes, 32, 46

Speeding, 57, 70
Speedometers, 31, 70
Speed trials, 89-91
Spencer, Percival, 82
"Spirit of Ecstacy", 44
Stanley Company (US), 27
Steam engines, 11, 13, 27, 47, 59, 72, 90, 93, 96, 97, 102, 105 *see also* Traction engines
Steam Rollers, 47
Stellite, 101
Stepney wheel, 43
Stour, river, 77
Sunbeams (car), 58, 91
Suspension, 14, 17, 39
Swan (car), 36
Sykes, Charles, 44

Talbot, 32, 91
Tandems, 13, 22, 25
Taxis, 107-10
Telephone, internal, 34
Thompson, R. W., 11
Threshing Drum, 13
Tin Lizzies, *see* Ford
Towcester, Northants., 50
Traction engines, 13, 47, 93, 94, 95
Trams and tramlines, 58, 59, 102
Tricars, *see* Tricycles
Tricycles, 13, 22, 24, 38
Triumph (car), 62, 67
Turnpike Trusts, 11
Turpin, Frederick, 66

Van Toll, J., 19
Vauxhall, 37, 92, 101, 108
Volk, Magnus, 45
Vulcanisers, 48

Wagonettes, 106
Washroom fittings, 35
Wayzgoose outings, 94
Welbeck Park, 89
Werner, 61
Weston-super-Mare, 90, 106
Whippet trailer, 22
White sheet, photographing with, 10
Wickham Bishops, Essex, 86
Wilmington Giant, Sussex, 74
Wimborne, Dorset, 71
Winchester, Hants., 27, 94
Windsor, Berks., 17
Winton (car), 29
Witham, Essex, 49
Wolseley, 29, 51, 89